Why Art ?

Why Art?

Florence Margaret Daniels

Nelson-Hall ✧ *Chicago*

Library of Congress Cataloging in Publication Data

Daniels, Florence Margaret, 1921-
 Why art?

 1. Art appreciation. I. Title.
N7477.D36 701'.18 77-28084
ISBN 0-88229-173-4 (cloth)
ISBN 0-88229-604-3 (paper)

Manufactured in the United States of America

10 9 8 7 6 5 4 3 2 1

For George

Contents

Preface

The purpose of this book is to explain art in non-technical terms to those who have had little or no background in its study.

Interest in art has increased because of wider travel, both in the United States and abroad. Also, with more leisure time, many people are getting involved with the arts. Museums in great numbers are providing art courses in addition to housing and displaying art. American art today is very much alive. As a nation, we are looked upon as leaders in the art world, yet much of our population remains uninformed.

Therefore, this book has been written to meet the needs of a diversified audience and is directed to the following: the general reader who, as a spectator, wishes to enrich his life by learning more about art; the casual viewer who wants to develop a further understanding of art; the amateur artist who wants to add more to his art background; and the students of secondary school, or college, enrolled in art or humanities courses, who will find this book a useful text.

No amount of reading about art can take the place of actually seeing it. This book is written to serve as a guide to appreciating art. References are made to artists, works of art, and methods of producing art in hopes that the discussion will send the reader to museums, galleries, fairs, public buildings—wherever there is an opportunity to look at original art. Nearly everyone in the United States today has access to viewing original art, and many museums have galleries where patrons can rent paintings or art objects for a nominal monthly fee.

If a museum visit is out of the question, reproductions are widely available, often on a borrowing basis from libraries or museums. Museums usually sell reproductions and rent or sell art slides. Original art can be purchased from art galleries, museum shops, and sometimes directly from the artist.

Art reproductions in books are much less satisfactory. Paintings are made to hang on walls, and sculpture is made to be viewed in the round. Looking at a map of New York City is not like viewing the actual city any more than looking at pictures of a particular work of art is like looking at the actual object. The photographs reproduced in this book are included merely as illustrative material to clarify the text.

The illustrations are placed in groups at the beginning of each chapter as a convenient reference for the reader to preview before delving into the chapter. I believe arranging the examples in this manner enhances and visually explains much of the reading material without interfering with or distracting from the train of thought while reading the written explanation.

Art is a human endeavor, as basic to mankind as music and dancing. Yet, many people feel divorced from art. Some believe art is mysterious or strange, others think artwork is useless and unnecessary, and others are wary simply because they do not know anything about art.

In America we believe in democracy and education for the masses, but in many instances education in art has been largely neglected in school curriculums. Some, considering themselves well-educated and open-minded, may look upon artwork as busy work or attack art with biased ideas and prejudices or regard art altogether as an unimportant activity.

The study of art is sometimes equated with the study of the history of man. To discuss art or to explore art trends is impossible without bringing in some history. However, this book does not emphasize chronological dates and periods in art, nor does it delve into the sociological, economic, political, or religious background in great detail. Only when necessary has such information been provided. Also, the life stories of artists are not given here; the art forms artists create are deeply satisfying apart from an account of their lives.

In my attempt to clarify and simplify the vast and complex art field, I have divided this book into three parts.

Part I, *The Viewer and Art*, gives suggestions on how to visit museums and ways to look at art, examples and brief discussions of contemporary American art, and a capsule summary of the how and why of today's art trends.

Part II, *The Artist at Work*, discusses art materials and

techniques and how artists arrange and combine the visual elements of color, value, line, texture, shape, and space to create a visual expression.

Part III, *Art and America the Beautiful*, reveals how art awareness results in the viewer really "seeing" his environment, a brief summary of our past and present architecture and our concepts of preserving and salvaging our American heritage, how art awareness leads to reforms in cities and the preservation of our wilderness, and how environmental awareness comes through education, particularly education in art.

PART I
THE
VIEWER
AND
ART

Experiencing
Art

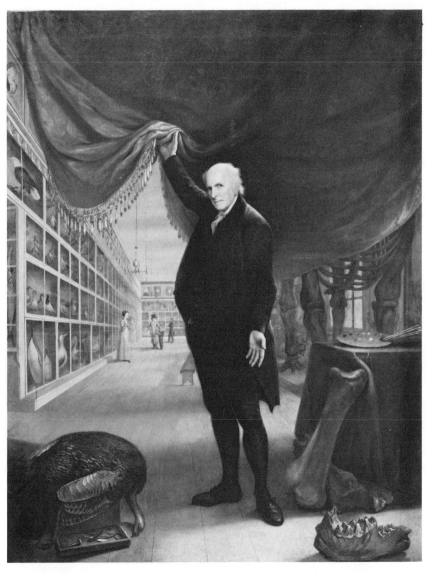

Charles Willson Peale. *The Artist in His Museum*, 1823. Oil, 103$\frac{1}{2}$ X 80 in. Pennsylvania Academy of the Fine Arts, Joseph and Sara Harrison Collection.

The Denver Art Museum Denver, Colorado. Architects: James S. Sudler, A.I.A., and Gio Ponti (Italy).

Raphaellè Peale. *After the Bath*, 1823. Oil, 29 X 24 in. Nelson Gallery-Atkins Museum, Kansas City, Missouri, Nelson Fund.

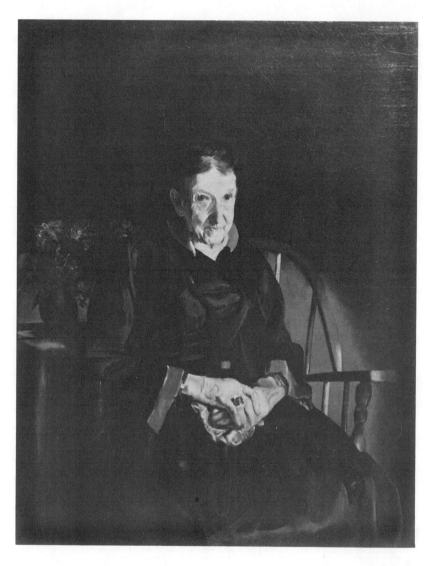

George Wesley Bellows. *Aunt Fanny*, 1920. Oil, 44$^{1}/_{8}$ X 34$^{1}/_{4}$ in. Des Moines Art Center, James D. Edmundson Fund.

Meret Oppenheim. *Object* (Fur-covered cup, saucer and spoon), 1936. Cup, 4³⁄₈ in. diameter; saucer, 9³⁄₈ in. diameter, spoon, 8 in. long; overall height, 2⁷⁄₈ in. Collection, The Museum of Modern Art, New York.

9

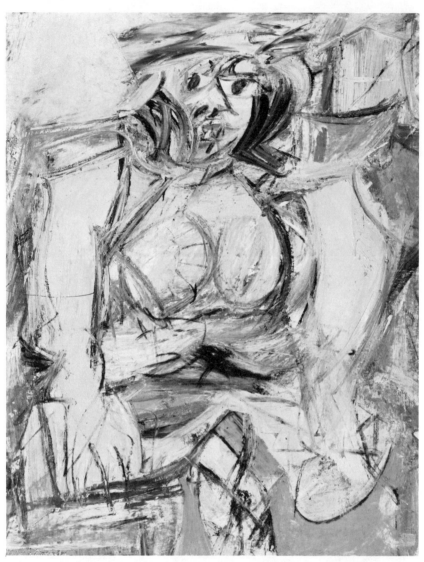

Willem de Kooning. *Woman IV*, 1952–53. Oil, 59 X 46¹/₄ in. Nelson
Gallery-Atkins Museum, Kansas City, Missouri, gift of Mr.
William Inge.

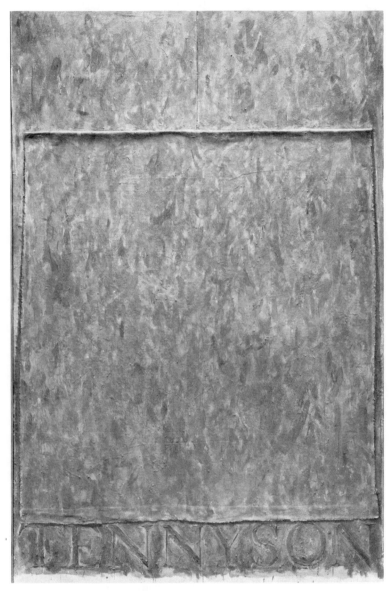

Jasper Johns. *Tennyson*, 1958. Encaustic and canvas collage, 73$^1/2$ X 48$^1/4$ in. Des Moines Art Center, Nathan Emory Coffin Fine Arts Trust Fund.

1

Experiencing Art

Experiences in art viewing are on a one-to-one basis, between the art viewer and the art form. Responses to art and appreciation of art do not come about by proxy; rather, the viewer must look at the art and experience it firsthand. Unfortunately, much of the visual communication is lost when art is reproduced. A photograph or a reproduction of a painting, a sculpture, or a building will not take the place of actually seeing the real thing. At best, reproductions are visual descriptions, like snapshots of friends or slides of a vacation. There is no substitute for viewing the original.

A museum visit to look at art is a good starting place. We do not have to travel to faraway places to see examples of many kinds of art because we have some of each in our own museums.

✱ All of us in the United States have the opportunity and the privilege to see art from every known civilization in the world and from every period of history. This privilege that we take for granted has not always been so in other countries at various times in the past, nor is it even so now, for that matter.

In addition to owning art from around the world, our museums are rich in American art. All American styles and periods are well-represented in our major museums. The story of our nation is vividly alive in our paintings and our sculptures. Our rich visual heritage includes the native art of the American Indian, unsophisticated art of colonial days, folk art, religious art, and art of contemporary America.

Museums were established early in the United States. Artist Charles Willson Peale built one of the first museums, in Philadelphia. *The Artist in His Museum* was painted by Peale in 1823.

Every city, large or small, has something to offer the museum goer. Throughout our country, each art museum and art center has a character of its own, with its own atmosphere and unique types of collections. For instance, the Chicago Art Institute has some of the finest nineteenth and twentieth century art in the world. One of the largest Oriental art collections outside China is in the Nelson-Atkins Museum in Kansas City, Missouri. Besides its historical and political interest, Washington, D.C., has one of the largest collections of art anywhere. The recent opening of the Joseph H. Hirshhorn Museum and Sculpture Garden has further enriched the art treasury in our national capital. It would take a lifetime to get to know all the art exhibited there. The same is true of New York City, es-

pecially since it is the center for contemporary art and the lively art scene and is considered one of the important art centers of the world.

The Whitney Museum of American Art in New York City is especially rich in examples of the first forty years of this century. When there were few buyers for American art, the founders of the museum purchased the works of many Americans who later became leading artists. The Whitney also owns a very large collection of contemporary American sculpture.

Certainly not all art treasures or viewing delights are found in large city museums. Colorado Springs, Colorado, is one of the few museums in the United States that has a thirty-five foot totem pole; and one of the most beautiful art buildings and grounds anywhere is found in Des Moines, Iowa. The building was designed by Eliel Saarinen, and an additional wing was designed later by I. M. Pei. Both men are outstanding in the field of architecture.

For the traveler going to Europe, two little-known but unusual museums are the Kröller-Müller, near Otterlo, The Netherlands, and Louisana of Denmark, north of Copenhagen near the Baltic Sea. The Kröller-Müller museum has 272 Van Goghs as well as works by other well-known artists.

Most of our American museums are free or charge only a very small admission. The casual visitor may be unaware of the educational programs for both adults and children. Many have college level art courses. Films, libraries, lectures, rental galleries, and sales rooms of original art are available in most major museums. Usually, art centers involve all of the arts and are active cultural attractions for the community.

During the past few decades many new art museums and art centers have been built across our country. The attractive Denver Art Museum is one of the newest buildings and the largest museum between Kansas City and the west coast.

Museum visits may be enjoyed in countless ways. Often the novice museum goer makes the mistake of trying to take in too much at one time. Above all, avoid museum fatigue. As a veteran museum goer, I would offer some advice to the novice.

Most museums are closed one day of the week, usually Mondays. To avoid the disappointment of a closed door, check schedules in advance.

Don't try to see everything, going from painting to painting and sculpture to sculpture. Every museum has a floor plan, an information desk, and a booklet about its collections. If you would like a guided tour, most museums have tours with knowledgeable leaders. Recorded explanations of the works with individual listening headsets are sometimes available to rent.

If you decide to go on your own, study the information plan before deciding what areas or rooms of art you wish to see. Larger museums have restaurants or snack bars. Some visitors prefer to arrive in time for lunch, study the museum-guide booklet, and plan a leisurely afternoon of viewing.

All of us have moods and may not want a structured visit. If so, ignore the information guide, and step into a room; go to look at that which personally appeals to you. Spend a few minutes enjoying the art form, then choose another in the same manner.

If possible, take a child with you, because young people relate well to art and may help to open your

eyes. Also, several short visits are much better than a few long ones, and a child with you will force you to a short visit. Visiting an art museum is like visiting with good friends. Go to see them often, but don't overstay your visit.

Getting acquainted with art can lead us into a world of great adventure. Surprise and delight await those who are willing to open their minds in order to allow their eyes to see as they did when they were young and marveled at everything in their surroundings. Children viewing art are not blinded by prejudices and opinions of others. As children we knew the "awe of seeing." Learning to look at art will help us again to capture the art of seeing. Because adults have maturity and the experience of living, seeing can become even more meaningful.

But we forfeit the aesthetic pleasures of experiencing the joy of seeing if we believe everything in the man-made world should be made for a practical purpose, because much of our art is created for pure enjoyment and pure visual pleasure. If we believe that looking at art is a waste of time, and that artists as a whole are an odd lot or worthless type of people, then we have blocked out seeing art.

We have to remove the veils from our eyes, the distraction from our surroundings, and the prejudices from our minds before we can experience an empathy with art. If we allow it, art can speak to our inner self. When the viewer develops an awareness and a feeling toward art, he may experience a sense of becoming a part of the art form itself, almost as if becoming transmuted into the painting or sculpture. Thus, the aesthetic response and experience of the viewer com-

plete the cycle of the creative act of art and the total art experience exhilarates the sensitive viewer.

Viewing pleasures are ours when we smile upon seeing the small delightful painting, *After the Bath,* by Raphaelle Peale, or inwardly greet George Bellow's *Aunt Fanny* because she reminds us of some gentle person we know.

When our fingertips feel the soft cool touch of a marble sculpture through our vision alone, when our tongue feels fuzzy and thick and our teeth tingle while we are viewing the fur-covered cup of Oppenheim, when we recoil from a de Kooning scream, or strain to hear the sigh of Jasper Johns' painting, *Tennyson,* then we are experiencing seeing art.

The more we look at art, the more visually sensitive our eyes will become. After learning to perceive in depth, the beginning viewer will learn to see and appreciate art. Hopefully, he will become an active participant or an enthusiastic viewer, rather than a passive onlooker. Discovering a response to art and the capacity to enjoy viewing it adds a deeper meaning to our lives and another dimension to our existence.

Stumbling blocks and patterned habits stand in the way of a novice learning to see in specifics rather than viewing art in fuzzy generalities. We are busy people in a fast-moving world, surrounding our lives with all kinds of instant visual material. Images on television and films, in newspapers and magazines, on billboards and posters are all designed to give information at a glance. Our eyes and our minds become conditioned to the immediate message.

Not long ago, I was looking at one of Ad Reinhardt's *Black* paintings in the Museum of Modern Art. I was

enjoying the different blacks, which range from deep, almost purple-black to a soft lighter blue-black, and the shapes within the blackness. As I stood there, two teen-age boys stopped and paused a second near the painting. "It's nothing but black," remarked one, shrugging off the painting with a glance. When the pair went to sit on a bench in the middle of the room, I deliberately stood in front of the painting for a while longer, hoping they would become curious. When I finally moved away, one of the boys went over to the painting, stood there a minute, and I heard him say to his friend, "Hey, come look. There is a cross in there."

Probably the first stumbling block the beginning viewer has to overcome is the tendency to rush from art work to art work, attempting to gobble it in huge quantities rather than viewing in a meditative or leisurely manner. Art forms are seldom created for a mere glance. Aesthetic responses can seldom come to the viewer who rushes from one painting or sculpture to the next, perhaps pausing to read the title or artist, then dashing on to the next work.

Another trap that often blinds the viewer to seeing art is the common belief that all art forms should tell a story. Indeed, for many centuries story-telling and subject matter were vital functions of art. Stories of the Bible, faraway places, portraits, and important events depicted in paintings or sculptures were invaluable forms of communication and education. The patrons of art and the viewing audience placed a premium on the artists' ability to imitate natural appearances, and many artists became exceptionally skilled in portraying realism. With the development and sophistication of the camera in this century, subject matter

and descriptive narrative art no longer remain the principal goals for the artist.

Although portrait painting continued as a very active and lucrative field for artists during the past century, landscape paintings became a very popular art form. The people were eager to see what this vast continent looked like. Naturally, they placed much emphasis upon skill in rendering a realistic interpretation of actual appearances.

Actual subject matter in art may lose its meaning to us over a passage of time, especially if a great deal of symbolism or mythology was used. Nevertheless, if the art has appealing form, it continues to remain significant as an art expression.

Because much of contemporary art is not concerned with recognizable subject matter, looking for a story or a subject hidden within a form stands in the way of appreciating the art.

The point is, we can appreciate art without knowing facts or understanding the purpose for its creation. We do not have to look at recognizable subject matter in order to marvel at the beauty, the color, the inventive skill, and the countless ingredients which go into making an art form. Native American art can be enjoyed without knowing the original significance of a warrior's headdress or the meaning of the rich and decorative abstract symbols woven into a rug or blanket.

A pioneer artist of today's art titled one of his paintings *Arrangement in Gray and Black, No. 1.* Most of us know the painting by its popular name, *Whistler's Mother.* When asked about the title, Whistler replied that it was an interesting picture of his mother, but,

"Ought the public care about the identity of the portrait?" He was concerned with expression and form as well as with the subject matter. His primary goal as a creative artist was to organize a painting as an aesthetic experience, not merely as a visual record of actual appearances.

Earlier, I mentioned taking a child with you to begin your viewing experiences. Children relate more freely to art because they are not inhibited or blinded by preconceived notions. Fixed ideas in our minds about what we think art should look like can block out much of our visual experiences. Viewing art with an open mind teaches us how to see and, in turn, art awareness opens our eyes to many things in the world around us.

As adults it is impossible to have a completely free outlook toward the world because of our experiences and our inherited attitudes through cultural development. Western eyes, until this century, were inclined to view Chinese or Japanese art as flat and decorative, and some believed Oriental art was less refined than Western art. Cultural blinders prevented explorers and settlers of this country from appreciating native American Indian art. Because the native art was different, many looked upon it as childish or worthless. Overcoming prejudices and peering beyond cultural blinders are the most difficult of all obstacles to overcome when learning to see and appreciate art.

Always accepting prevailing attitudes or inherited attitudes can block understanding and thwart new experiences in life, as well as in art viewing. Art is unlimited in its modes of expression, and it can reach through to us if we allow it. Nor does it matter in what part of the world the art was produced, or in what

period of man's calendar it was created; the art form can reach through when we learn to see. The entire creative process of an art expression has reached perfection when human eyes and human emotions have responded to the art creation of another human being. Appreciating art can lead to a deeper awareness of man and the world. Through enjoying art we become less inclined to ask, "Why art?"

Viewing
Contemporary
American Art

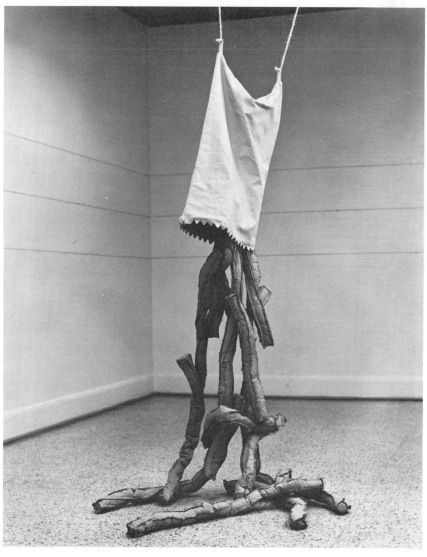

Claes Oldenburg. *Falling Shoestring Potatoes*, 1965. Painted canvas, kapok, 108 X 46 X 42 in. Collection, Walker Art Center, Minneapolis. Photograph by Eric Sutherland.

25

James Rosenquist. *The Light that Won't Fail, I,* 1961. Oil, 72 X 96 in. The Hirshhorn Museum and Sculpture Garden, Smithsonian Institution.

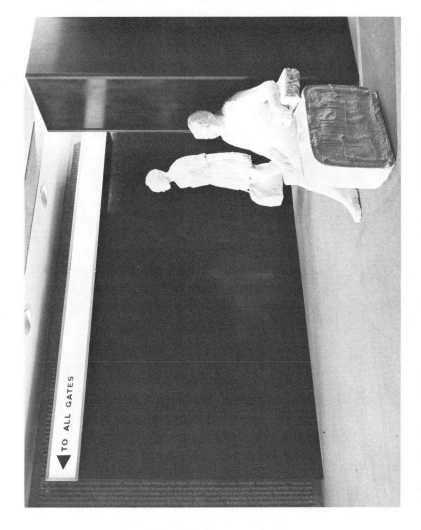

George Segal. *To All Gates*, 1971. Plaster, wood, plastic, lights, 96 X 144 X 90 in. Des Moines Art Center, Nathan Emory Coffin Fine Arts Trust Fund.

Andy Warhol. *Marilyn Monroe's Lips*, 1964. Acrylic and silkscreen enamel, two panels: $82^7/_8$ X $82^3/_8$ in., $82^7/_8$ X $80^3/_4$ in. The Hirshhorn Museum and Sculpture Garden, Smithsonian Institution.

Robert Rauschenberg. *Trophy II (For Teeny and Marcel Duchamp)*, 1960–61. Combined painting, 90 X 118 in. Collection, Walker Art Center, Minneapolis. Photograph by Gerald Stableski.

Larry Rivers. *Berdie with the American Flag*, 1957. Oil, 20 X 25⁷/₈ in. The Nelson Gallery-Atkins Museum, Kansas City, Missouri, gift of Mr. William Inge.

Stuart Davis. *Colonial Cubism*, 1954. Oil, 45 X 60 in. Collection, Walker Art Center, Minneapolis. Photograph by Eric Sutherland.

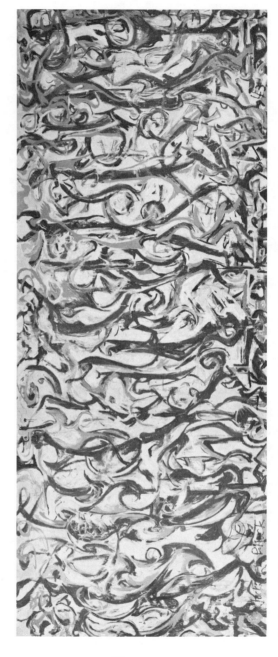

Jackson Pollock. *Mural*, 1943. Oil, 95³/4 X 237¹/2 in. The University of Iowa Museum of Art, gift of Peggy Guggenheim.

Hans Hofmann. *Smaragd Red and Germinating Yellow*, 1959. Oil, 55 X 40 in. Contemporary Collection of The Cleveland Museum of Art.

Larry Poons. *Via Regia*, 1964. Acrylic, 6 X 12 ft. The Hirshhorn Museum and Sculpture Garden, Smithsonian Institution.

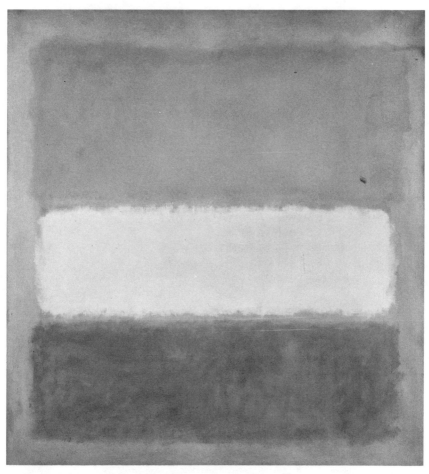

Mark Rothko. *Yellow Band,* 1956. Oil, 86 X 80 in. University of Ne-
braska Art Galleries, Nebraska Art Association, Thomas C.
Woods Collection.

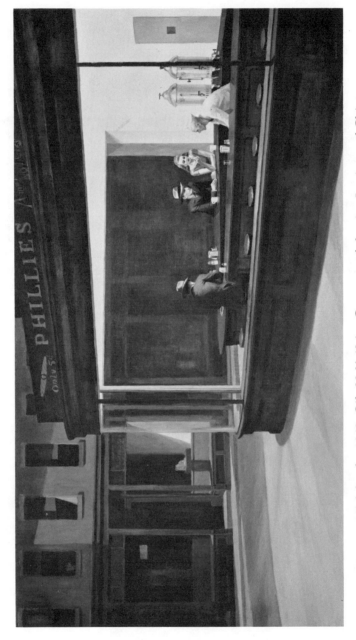

Edward Hopper. *Nighthawks*, 1942. Oil, 30 X 60 in. Courtesy of the Art Institute of Chicago.

Andrew Wyeth. *Christina's World*, 1948. Tempera on gesso panel, 32¼ X 47¾ in. Collection, The Museum of Modern Art, New York.

Ivan Albright. *That Which I Should Have Done I Did Not Do,*
1931–41. Oil, 97 X 36 in. Courtesy of the Art Institute of Chicago.

Frank Stella. *Damascus Gate Stretch Variation*, 1968. Acrylic, 5 X 25 ft. Collection, Walker Art Center, Minneapolis, gift of Mr. and Mrs. Edmond Ruben, Minneapolis. Photograph by Gerald Stableski.

David Smith. *Cubi IX*, 1961. Stainless steel, 106¹/₄ X 56 X 46 in. Collection, Walker Art Center, Minneapolis. Photograph by Eric Sutherland.

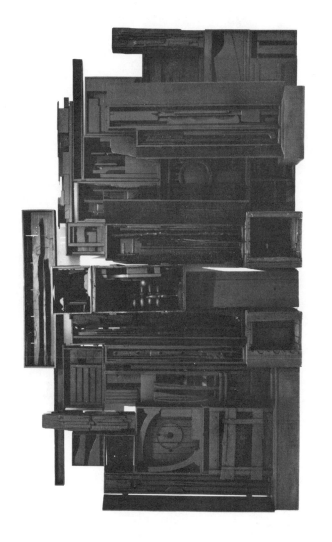

Louise Nevelson. *Sky Cathedral Presence*, 1951–64. Wood painted black, 117 X 174 X 29 in. Collection, Walker Art Center, Minneapolis, gift of Mr. and Mrs. Kenneth N. Dayton, Wayzata, Minnesota. Photograph by Eric Sutherland.

2

Viewing Contemporary American Art

L ooking at art created in America today is an
excellent starting point for the novice
viewer, especially since the contemporary Ameri-
can art scene is very diverse and imaginative and
exuberantly alive. Limitless possibilities are open for
creative people who live in an atmosphere where
creativity and individuality are encouraged and nur-
tured. Certainly, contemporary American art is
unique in its wide spectrum of innovative forms.

Like "frozen music" the paintings and sculptures
appear as if posed, ready to enchant the viewer. No
wonder some societies believe art has magic powers.
The dazzling array of shapes and colors is breathtak-
ing. Some of the art forms hang on the ceiling, others
appear to grow from the walls and protrude into our
human viewing space, and some paintings go around

corners, while others seem to climb up and down the walls.

Do not be concerned if you feel that you do not understand what you see. Much of the meaningful part of life cannot be understood, or for that matter described. In the early part of this century when Picasso was working with cubism, someone said to him that he did not understand his work and wanted to know what it meant. "Must art have a meaning?" Picasso asked. "Do we have to know what the song of a bird means?" He went on to say that flowers can be enjoyed without understanding them. If you wish to truly enjoy art, heed the advice of Wordsworth: "Come forth and bring with you a heart that watches and receives."

Viewing pop art is a good beginning for the novice art viewer because the art focuses on our everyday life. The pop artist copies and interprets our man-made world, captures our views and values, then presents an art form using recognizable objects or images. Like a mirror, the art reflects our surroundings and our values to us. Only it is a crazy, mixed-up mirror much like those of amusement parks; our material world and human values are seen from many angles and distortions.

Some of the artists, like Claes Oldenburg, create everyday objects into such gigantic proportions and sizes the viewer feels as if he is a Lilliputian gazing at the object. Are we really aware of what we see in our daily lives? Do we take everything for granted without really noticing it? Can you describe or sketch a telephone from memory, or visualize the telephone in an art form that fills an ordinary room or in Gargantuan size filling a gymnasium?

After looking at Oldenburg's *Falling Shoestring Potatoes*, it is likely we will never look at a sack of french fries with the same eyes as before.

When viewing the art of James Rosenquist, the art appreciator again feels as if transformed into a tiny spectator in the world of giants. The artist magnifies segments of American life; events and prosaic objects are enlarged to extreme size, faithfully rendered in complete detail. Often, Rosenquist combines happy occasions with horrifying events. Because of the size of the paintings, the viewer feels surrounded and overwhelmed, a sort of small particle caught in a large diabolical universe.

Kennedy

George Segal, on the other hand, creates sculptural environments of life size. In addition, he often uses actual objects from our material world and creates a stage-like art form for our visual involvement. The white, ghostly figures appear as if they are actual people, trapped in a cast, covered with bandages from head to toe. These eerie and anonymous creatures live and work in a world much like our own, but they exist as zombies or bandaged robots going through the motions of living. His art may stir within us varied reactions, perhaps a sense of insecurity or loneliness, or of everyday life as dull and unexciting. "Are we just a face in a crowd? What is the purpose for our existence?" his art seems to ask.

Turning to the work of Andy Warhol, most viewers will recognize his name immediately because of his popular paintings of Campbell soup cans, and Brillo box sculpture, and his silkscreens of Marilyn Monroe, Elizabeth Taylor, and Elvis Presley, which have become a part of our everyday culture. Sometimes Warhol repeats an image over and over again, many times

in one art form, perhaps suggesting life in modern society may be a humdrum existence. He has also done a great deal of work with films and movies. Artists today do not feel tied and bound to one kind of material. They explore the possibilities of using new ideas with film, light, motors; the imagination of the artist knows no bounds, a "leap into the unknown." Artists invent and contrive endless possibilities for creating a more dynamic visual expression that will open the eyes of the viewer to a deeper visual awareness.

Robert Rauschenberg is an artist who works with combined materials. Attached objects to a painting or combinations of objects into an art form are accepted by the viewing public today, but when Rauschenberg held an exhibit back in 1955, some of his constructions caused quite a stir. Critics had a heyday with an art form that Rauschenberg had titled *The Bed.* It is made of a part of a quilt and a pillow, and paint is boldly splashed in abstract shapes over the objects. The construction of combined elements is attached to a rigid surface and hangs on a wall like a relief sculpture. The illustration of his *Trophy II (for Teeny and Marcel Duchamp)* is an example of his more recent work. It is a very large combined painting and collage of actual objects. The art form does not fit into a preconceived early-century concept of either a painting or sculpture.

Another artist, Larry Rivers, combines techniques and materials, often including paintings, drawings, and areas of untouched canvas within one art form. Sometimes the realistic appearing subjects are fragmented images arranged into a composition. He is skillful and sensitive in presenting his ideas visually, often following a theme of history or social comments.

One of the outstanding qualities apparent to the novice viewer is the skill of today's artists, versatile and accomplished in handling many kinds of materials. Sometimes the lament may be heard, "Why don't we have artists like Michelangelo or da Vinci today?" Equally skillful and imaginative artists are working today, but the art forms are expressed in different styles, with different ideas, using the materials of our twentieth century world.

Close

Our imaginary viewing discussion has examined an art which focuses upon our American culture, an art which asks us to take a second look at the objects around us, the concepts and values of our culture. Perhaps you did not like some of the examples discussed or some original pop art you have seen. Having likes and dislikes are natural human responses. Since art deals with the whole realm of human emotions, it has something for everybody to enjoy, like music, literature, movies, or plays.

Some people associate "fine art" with the words "refined" or "elevated" art, mistakenly thinking paintings or sculpture are too far removed from them to enjoy. Pop art should quell any fears the timid viewer may have regarding art as too elevated and beyond his reach.

Art can be argued fanatically and indefinitely, like religion and politics. For years, art critics have been battling over abstract art versus realism, American art versus European art, and so on. Taste and modes of visual art expressions are relative to time and place. Art which may be considered good taste in one period of history or a specific culture may be considered bad taste in another culture or another time.

Enjoying art is not dependent upon the opinion of others. Novice viewers often have a narrow scope of preferences, but increased art viewing expands horizons to encompass a larger selection for viewing pleasure and acceptance.

Art expression takes many directions and forms. In a sense, all art is abstract in the beginning when the creative process begins in the artist's mind in abstract thought. The final art form may be abstract images or realistic appearing images, or a combination of both. Pop art is largely expressed with recognizable subject matter and realistic images. Picasso's work always depicts recognizable subject matter, but many artists have eliminated recognizable images entirely from their art. When abstract art goes beyond the first instant level of identifiable subject matter, the viewer is face-to-face with the visual language of color, line, shape, texture, and space. Along with the visual delight of perceiving with our eyes, we sense the feeling and the mood, the transference of ideas, and the appeal to our imagination and to our intellect.

Abstract art is certainly not new to this century nor new to this continent. Native North American art was always abstract. Living in the world of nature inspired the Indian artists to create art, abstracting shapes and form from the natural shapes of animals, birds, and plants. In historical development of art, abstract art can be traced back to the dawn of man. Indeed, our alphabet evolved from abstract symbols and picture writing.

At the beginning of this century some American artists started to work with abstract art. Stuart Davis was one of the early artists who pioneered American ab-

stract art. His painting *Colonial Cubism* is an example of his later style; always his art showed an exuberance for American life. Often, his compositions are humorous, and some paintings combine words along with abstract symbols. Much of his art seems inspired by music, not soft harmonies, but fast tempo, wild, but not chaotic, always unified into a composition of dazzling, intense color, "music for the eyes." Unfortunately for the reader, art expression dies in a reproduction.

Some abstract painters, for example, Jackson Pollock, Hans Hofmann, Larry Poons, and Franz Kline, have created painted environments that seem to pull the viewer into their simulated world. The dynamic force and inner structures of the huge canvases surround, envelop, and overwhelm the spectator. Careening into infinity, the viewer is buffeted by twisting spirals or flying elipses, becoming dizzy, whirling, stimulated by brilliant color pulsating with energy.

Paintings like Mark Rothko's entice the spectator into the art form with soft whispers, enthralling the viewer with smoky shapes and quiet colors, lulling him into an ethereal state.

Each artist is a unique individual creating his own visual forms of expression. The art may be humorous, cheerful, dynamic, moody, mysterious, sad; every aspect of human emotion and human experience is visually expressed. The viewer, like the artist, selects and reacts and responds to the art with his own background of experiences and interests, relating more deeply to that which is more meaningful to him.

Because art is an expression of a special way the artist sees the world, some artists' work may come through to you stronger than others. Naturally, we re-

act with our own responses, but we should not be afraid to change our ideas about art. Learning to appreciate some art is like learning to know some people—reserve a definite opinion until better acquainted. Enriching experiences vastly different from those we've known before may later become a part of our own as we become art appreciators.

Art has variety and attraction for every viewer to enjoy and appreciate. Some viewers may equate loneliness more with Edward Hopper's *Nighthawks* than with a Rembrandt self-portrait; or perhaps Andrew Wyeth's *Christina's World* expresses more pensiveness and deeper pathos than a painting of abstract expressive images.

For viewers who admire precise, meticulous detail and skillful drawing and painting as exceptional qualities in art, Ivan Albright's *That Which I Should Have Done I Did Not Do* is strongly appealing; and his skill does not overshadow the emotional appeal. Other artists working in a similar realistic style may attract viewers who like surprises or combinations of unusual visual images and unrelated themes transformed into dreamlike interpretations.

Some viewers relate more readily to geometric images in abstract art than to expressive, emotional abstract forms, while others have opposite reactions. Those viewers liking precision in abstract art will appreciate the art form created by Frank Stella. His *Damascus Gate Stretch Variation* expresses a controlled painting rather than a painterly style, as for example in contrast to the work of Hofmann or de Kooning.

Artists whose art concepts are similar to those of Stella usually eliminate the appearance of brush

strokes and textural effects, concentrating on abstract shapes with precise, razor-sharp edges separating the shapes, and using clear, vivid, and intense colors. The shapes may take the form of stripes, bull's-eyes, chevrons, squares or discs. The colors can be brilliant and contrasting, creating an illusionary effect of vibrancy or depth similar to op art; or, the color value—lights and darks—may be held within a very narrow range, a minimal amount of contrast, like the black paintings of Ad Reinhardt.

Frank Stella often invents unusual shapes instead of using the conventional square or rectangle form. Sometimes he attaches brightly colored geometric shapes to surface upon surface, creating a three-dimensional, sculptural-like painting.

Geometric abstract shapes are used in sculpture, too. David Smith's *Cubi IX* is a large sculpture of stainless steel, standing as if an austere monument to twentieth century technology. The viewer senses an intensiveness and vigor radiating from his work. David Smith was one of the first American artists to explore welded sculpture of iron and steel, leading the way to innovative uses of metals in art.

During the last half of the twentieth century, artists have explored and invented new art forms using every conceivable kind of materials. Louise Nevelson's *Sky Cathedral Presence* is a wall-size relief sculpture made of found wooden shapes, arranged in box-like compartments, and entirely painted with dull black paint. Her sculpture is an environment that surrounds the viewer with the discards of our society: wood objects, furniture parts, or scraps from old buildings.

Artists like David Smith take the raw products of

our world and forge them into an art expression, while those working with concepts of Louise Nevelson create art forms with discarded material, recycling the throwaways of modern society.

After viewing contemporary sculpture and painting, the viewer is conscious of two outstanding features of today's art: the tremendous variety of materials used by the artists, and the diverse, seemingly endless modes of interpretations and artistic expressions.

No longer are paintings of nearly uniform shapes, sizes, and styles hanging neatly in precise rows around the exhibit room. Today, if canvas is used for a painting it can take every conceivable form; it may have protruding shapes; it may hang limp from the wall in folds like a curtain; or the canvas may be deliberately cut, ripped, frayed, or covered here and there with patches and the like, with no limit on the artists' imaginations.

Nor is sculpture confined to stone, wood, or bronze, with the human image as its primary model. Sculpture may be abstract shapes and assemblages. Sculpture forms may twist, shudder, jerk, whir, buzz, or quietly glide through space, moving with air currents like one of Alexander Calder's mobiles. On the other hand, some sculpture forms, as if imitating a pile of junk, sit motionless, silently and accusingly, reminding the spectator of his wasteful, throwaway culture.

Today's generation of art viewers look upon extremely different kinds of visual images than did either their parents or grandparents. The rigid lines of demarcation and conformity have disappeared in art. The curious art spectator, as he delves further into art

viewing, will ask himself how and why art has changed so drastically. Looking at exhibits of late nineteenth and early twentieth century American and European art will unfold the story of new concepts and innovations that led to art forms of today.

How
and
Why
of
Today's Art

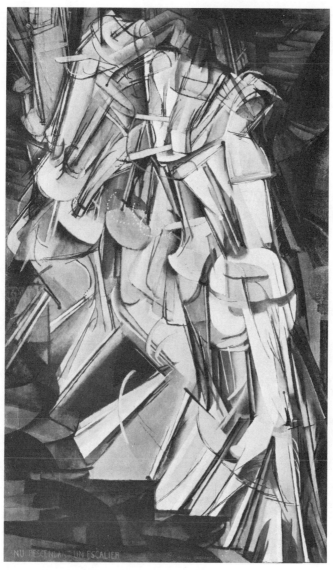

Marcel Duchamp. *Nude Descending a Staircase, No. 2*, 1912. Oil, 58 X 35 in. Philadelphia Museum of Art, The Louise and Walter Arensberg Collection.

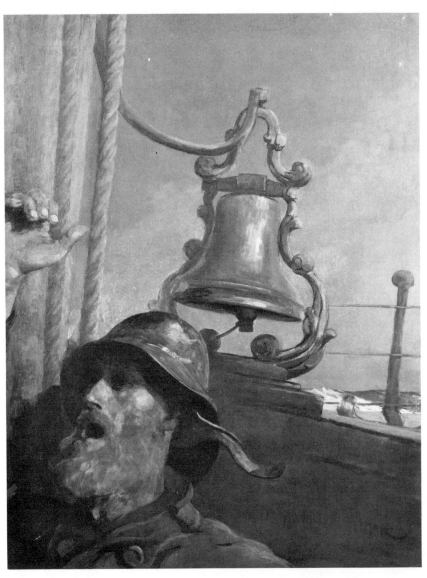

Winslow Homer. *The Lookout — "All's Well,"* 1896. Oil, 40 X 30¼ in. Courtesy of the Museum of Fine Arts, Boston, William Wilkins Warren Fund.

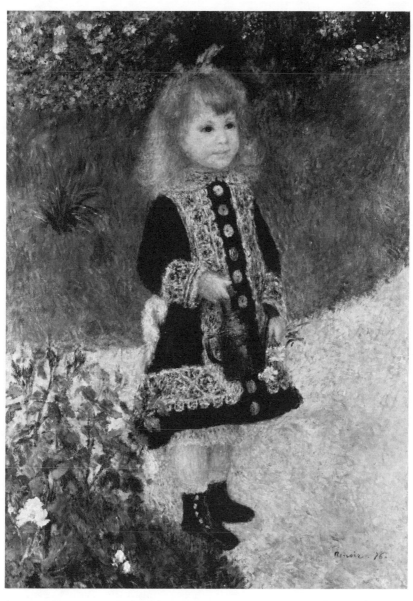

Auguste Renoir. *A Girl with a Watering Can*, 1896. Oil, 39¹/₂ X 28³/₄ in. National Gallery of Art, Washington, Chester Dale Collection.

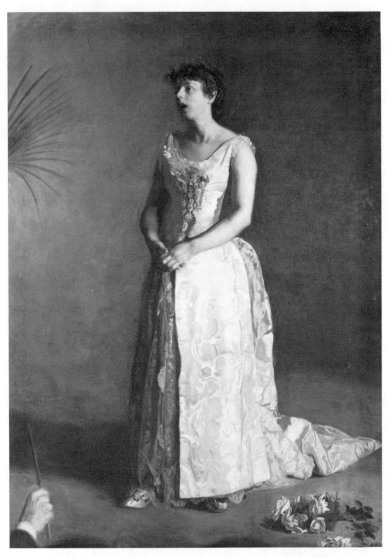

Thomas Eakins. *The Concert Singer — Portrait of Weda Cook* (Mrs. Stanley Addicks), 1892. Oil, 75³/₈ X 54³/₈ in. Philadelphia Museum of Art, gift of Mrs. Thomas Eakins and Miss Mary A. Williams.

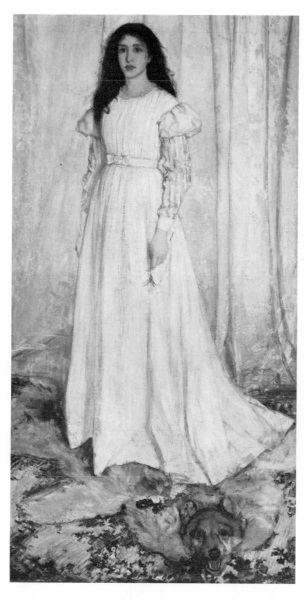

James McNeill Whistler. *The White Girl*, 1862. Oil, 84¹/₂ X 42¹/₂ in. National Gallery of Art, Washington, Harris Whittemore Collection.

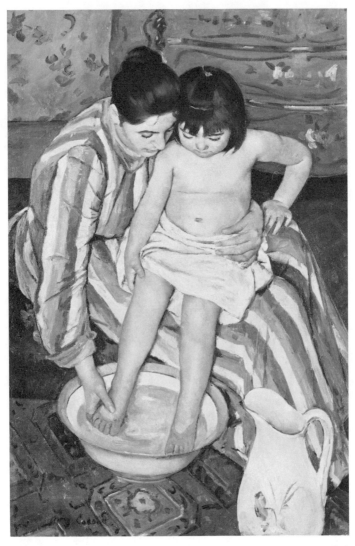

Mary Cassatt. *The Bath*, 1891. Oil, 39 X 26 in. Courtesy of the Art
Institute of Chicago.

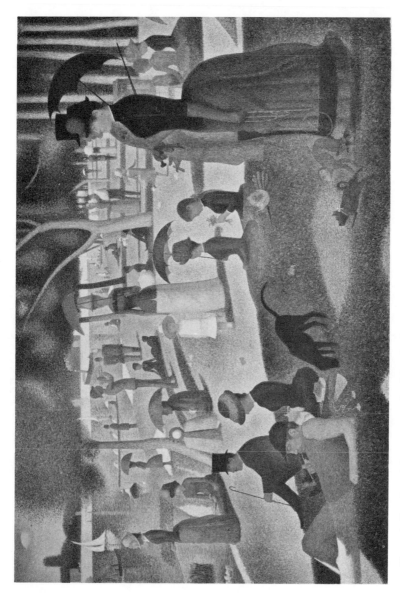

Georges Seurat. *Sunday Afternoon on the Island of La Grande Jatte*, 1884–86. Oil, 81 X 120³/₈ in. Courtesy of the Art Institute of Chicago.

63

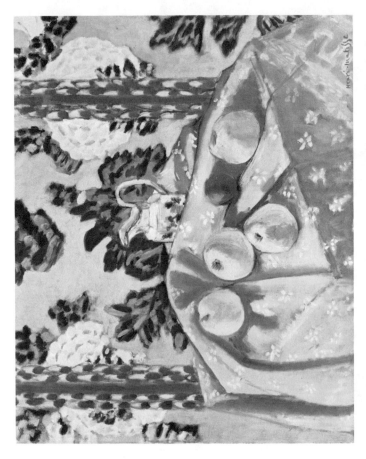

Henri Matisse. *Still Life: Apples on Pink Tablecloth*, c. 1922. Oil, 23³/4 X 28³/4 in. National Gallery of Art, Washington, Chester Dale Collection.

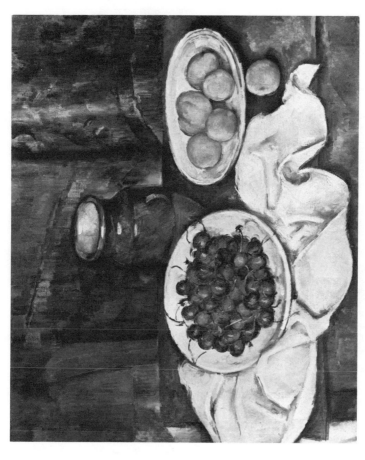

Paul Cezanne. *Still Life with Cherries and Peaches*, 1883–87. Oil, 19³/₄ X 24 in. Los Angeles County Museum of Art, gift of the Adele R. Levy Fund.

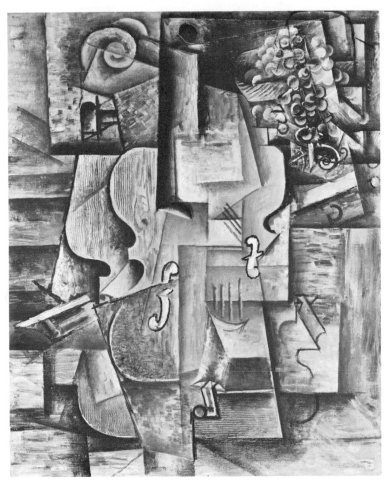

Pablo Picasso. *Violin and Grapes*, 1912. Oil, 20 X 24 in. Collection, The Museum of Modern Art, New York, Mrs. David M. Levy Bequest.

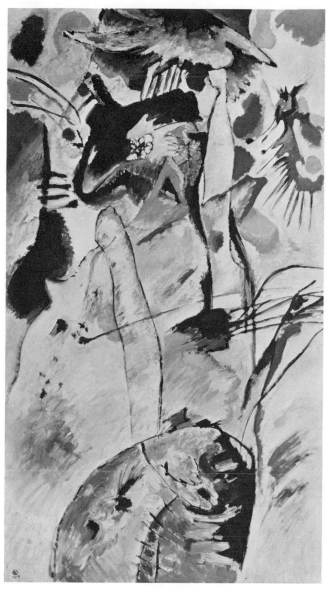

Wassily Kandinsky. *Panel (3),* 1914. Oil, 64 X 36¼ in. Collection, The Museum of Modern Art, New York, Mrs. Simon Guggenheim Fund.

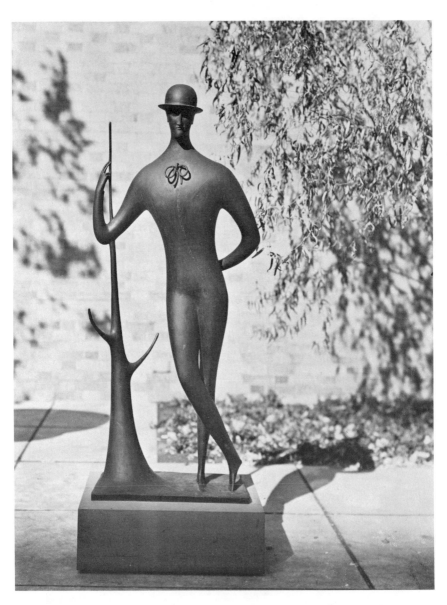

Elie Nadelman. *Man in the Open Air*, c. 1915. Bronze, 54^1/$_2$ in. high X 11^3/$_4$ X 21^1/$_2$ in. at base. Collection, The Museum of Modern Art, New York, gift of William S. Paley.

John Marin. *Movement, Fifth Avenue,* 1912. Watercolor, 16⅝ X
13½ in. Courtesy of the Art Institute of Chicago.

Georgia O'Keeffe. *Lake George Barns*, 1926. Oil, 45 X 60 in. Collection, Walker Art Center, Minneapolis.

3

How and Why of Today's Art

Many of the concepts of contemporary art were formulated early in this century. Artistic expression expressed in such diverse ways as pop art; junk sculpture; multimedia presentation of poetry, drama, music and art; happenings; earth sculpture; and environmental art assemblages are examples of concepts which evolved during and immediately following World War I.

At first the movement was more a frame of mind than a specific art expression. However, as the ideas evolved, art forms emerged which have had far-reaching effects upon art, especially the past few years.

In the beginning groups of young people, disillusioned with World War I and the values of the culture, gathered in European and American cities.

Young intellects protesting against the conditions of the times held exhibitions ranging from the zany to the ridiculous to gain attention and to jar public apathy. Their absurd actions were sometimes in the forms of cabaret performances in outlandish costumes, poetry readings or art exhibits. They questioned every facet of the values of the society with antiwar, antiliterature, and antiart activities. Even the word "dada," chosen as a name by some European groups, was a unique, apparently meaningless name, perhaps alluding to the first sounds uttered by the human infant.

The antiart of dada consists of illogical combinations of art forms. Junk was assembled into sculpture, the purpose of which was to question the importance of the value of art or the function of art in a world rife with evil and misery. Some of the artists in the group worked with accidental shapes of collage materials, creating art through intuition, avoiding all characteristics of the real world.

Marcel Duchamp made one of his "readymades," as an antiart sentiment, by painting a mustache and goatee on a reproduction of da Vinci's *Mona Lisa*. This bizarre act was to express his feelings that art had become too expensive and too precious. During the World War I years when French artist Duchamp came to live in New York, he was well-known in this country, not for his dada activities, but for his *Nude Descending a Staircase* and his interest in the fourth dimension in art imagery.

Some of the bitterness and pessimism of dada died out for a while, but the concepts surfaced again in art in the fifties and continue to be extremely pervasive in today's art, with further innovations in art forms.

Before World War I there had been outstanding bursts of activity in art expression, with much experimentation in the visual language of color, line, shape, texture, and space. New concepts and radical innovations resulted in new ways of seeing and new forms of visual communication. The flurry of art activities at the beginning of this century were extreme and radical in comparison to any of the past. The preceding illustrations at the beginning of this chapter cover a relatively short span of time, and the changes from the traditional to experimental unfold a visual story almost like a musical score changing from a slow waltz to electronic rock.

The examples used are either well-known paintings or works of outstanding artists. Although the styles, art concepts, and art expression are different, they are exceptional in their excellence. The illustrations were chosen to show the radical changes in artistic thinking. These changes are very apparent when comparing Winslow Homer's *The Lookout—"All's Well,"* painted in 1896, with Marcel Duchamp's *Nude Descending a Staircase, No. 2,* of 1912. During those years of extreme art changes, Western culture was also changing from agrarian societies to industrial nations. Great strides were made in science and technology. Sophisticated cameras freed the artist from his long role as portraitist and representative recorder of people, places and events. Scientific thinking about time, space, and motion; advances in color theories; and expanding horizons in all areas were factors that helped lead the direction toward new art concepts.

Early artists breaking away from traditional art did not turn their backs on realistic images. They were re-

volting against the same trite themes, the rigid rules and methods used throughout European art schools. Since most American artists at that time received their art training in European academies, the traditional art concepts were brought back to the United States. The art of the day was much the same style of realism, with smooth brush strokes of paint, often with highlights of lighter, perhaps thicker paint; dark colors were used with a great deal of shading and blending and a great concern for detail. Often the art forms were stale copies of earlier art without creative or individual interpretation.

The new art forms emerging at the end of the last century were not readily accepted by the viewing public. When today's viewers look at the paintings of Seurat, Renoir, Cassatt, or Whistler, few can imagine the stir the art caused. It seems unbelievable the paintings were looked upon as outlandish and crude. But the artists were exploring new ways of seeing, turning away from old forms and inventing new ones.

Many of the art forms and art concepts during those innovative years have been given names or labels, often ending in *ism*, as impressionism, cubism, dadaism, and so on. The story of the artists working with these early groups and innovative art ideas is the story of the birth and struggle for life of our contemporary art. Like the metamorphosis of the butterfly from its cocoon, art has struggled free from its restrictive bondage of rigid rules and stifling formulas.

The going was rough for the artists daring to present new visual ideas. Volumes have been written about them and their struggle for acceptance. Mary Cassatt's tender and sensitive mother-and-child paintings and

drawings, the beautiful women and children in the luscious colors of Renoir, the technical work and patience of Seurat's dot paintings, Van Gogh's vibrating hues and writhing shapes, Cezanne's still lifes and vistas, all are paintings loved and admired by the public today. Their paintings attract visitors in every museum, and the prices of the original paintings are out of reach for most people.

Nor do we cease to admire the traditional art like that of Homer and Eakins. Thomas Eakins' bold, forthright and honest expression of realism and Winslow Homer's unique and penetrating power of observation and innovations with watercolors are also admired and enjoyed by today's viewers. The point is, viewers today can accept the fact that art language can be expressed in more than one visual form.

When artists started to explore and experiment with the visual language, color was naturally one of the first artistic elements to break from traditional bonds. In fact, color innovations became a critical issue for James A. McNeill Whistler, who became involved in a lawsuit at the end of the last century. The court trial became the news of the day for Londoners and exciting news in art circles in the United States. The English art critic and reporter John Ruskin had inquired in his writing if splashes of paint on a canvas could be considered art. He accused Whistler of "flinging a pot of paint in the public's face." Whistler sued and won the trial, considering it a moral victory. The painting causing the uproar, *The Falling Rocket: Nocturn in Black and Gold*, was painted about 1874. A reproduction of the painting is not used here because it would give a false impression of the original, especially in a black and

white illustration. Even the original painting appears quite sedate and mild to our modern eyes. The illustration *The White Girl* is an example of a painting made several years before his innovations with color and before the lawsuit.

Like Whistler, Mary Cassatt was an American citizen who also spent much of her life in Europe. *The Bath* is an example of her paintings made in Paris while working with the "rebel" French artists who were revolting against old art ideas. Their canvases were becoming much lighter in overall tone and the colors more pure, not the muddy browns or grays and muted tone of most of the paintings of the day.

Some of the French artists such as Renoir and Seurat thought of the colors on their palettes as "rainbows" of color, looking upon their painting as scientific experiments with colors. They used daubs, dots, or small strokes of color, side by side, sometimes allowing the canvas to show through unpainted. Also, they went outside to paint, which was unthinkable at the time. Artists often went outdoors to sketch, but nearly all felt duty-bound to their studios for the more complicated and grander art form of painting.

Georges Seurat used dots of paint to capture with colors the vibrancy of light and the illusion of the atmospheric qualities of light. *A Sunday Afternoon on the Island of La Grand Jatte* is an illustration of his scientific formula consisting of small, uniform dots of color, sometimes called pointillism. His system was based upon a theory of color blending in the eyes of the viewer during the seeing process. That is, a dot of yellow placed next to a dot of blue would blend to green in the optical process of seeing, and a dot of red placed

next to a dot of blue would result in the viewer seeing the color violet, and so on. The technique was very time consuming, and the forms often appear rigid and austere. The theory sometimes fell short, despite the sincere efforts of artists working with the idea.

The French artist Henry Matisse invented with colors in an entirely different direction. Many contemporary artists admire his color innovations above all other artists of that period. For Matisse, colors were the life and purpose for the existence of a painting. Although he painted conventional art themes of recognizable subject matter, his canvases became blazing, dazzling worlds of color, not colors of a prosaic world, but pure, rich, joyous colors, unrestricted, uninhibited, wild, free of past formulas. There were no brown trunks and green leaves for trees in a landscape painting by the "wild beasts," as Matisse and his co-artists were dubbed; their realistic tree shapes became color shapes of warm lavenders, hot pinks, cool light blues—luscious hues of never before heard-of color combinations. "Red apples on a pink tablecloth? Red should never be used along with pink!" decried the critics.

Few artists working with new color theories or new color concepts met with high praise or public approval in the beginning; some, never in their lifetimes. Van Gogh's paintings, after he discovered the importance of colors to his style, were criticized by nearly everyone as too garish, too bright, too crude and unfinished and in poor taste.

Today, many viewers admire Van Gogh's art, and those viewers who look upon Van Gogh as a hero in modern art consider the Kröller-Müller museum in

Holland as a mecca for homage. Viewers entering rooms filled with his paintings are thrilled with the vivid hues dancing from the canvases, surrounding, saturating, submerging—an experience of intense color sensations.

Paul Cezanne, on the other hand, heard a different drummer. Colors were valuable art tools for him, but they played only a part in his interpretation of a new visual concept. He was more concerned with space and depth in a painting, breaking away from the older concept of static, frozen space of the traditional art. Cezanne did not regard the picture surface as a window through which to view the world, which had been the thinking since the Renaissance; instead, he handled the picture plane as a shallow, two-dimensional surface.

Through eliminating details and reducing objects to basic forms, Cezanne concentrated more on overall treatment of space. In his new concept of depicting depth on a flat surface, he invented a new technique of perspective, based upon the traditional fixed-focus perspective, but he used several eye-level views in one painting instead of the traditional one eye-level view. He tilted planes and elipses, adding a line here and there when needed for emphasis upon form.

For example, in a still life he would depict vases, teacups, or fruit from various eye-level views as a means of strengthening the design of the composition, giving more life to the canvas. In working with color, he took advantage of the illusions of receding cool colors and advancing warm colors. His subtle choice and placement of daubs of colors added to his concept of time and motion in a painting.

A retrospective of Cezanne's work after his death, an increased interest in Einstein's theory of relativity, and work with kinetic theory of matter were probably all influential in the development of cubistic art. Artists such as Picasso, Duchamp, and others started to experiment with shapes and planes, attempting to produce further an element of time and movement in painting images. In seeking the illusion of the fourth dimension, they pictorially shattered objects and rearranged them into a composition on the picture surface. They limited their range of objects and reassembled the shapes as seen from various angles and eye levels. They were seeking to present to the viewer the impression of the experience of walking into the picture space and around the objects as if seeing the objects from many views simultaneously. The objects were not completely abstract images, but recognizable subject matter.

Usually, artists working with the cubistic concepts restricted colors deliberately to a narrow choice, using subdued monochromatic color schemes as a means of avoiding all emotional appeal or attachment connected with color. Also, rhythmic or sensuous lines were rejected in favor of geometric planes, as Picasso's *Violin and Grapes* in the illustrations.

Pushing cubism a stage further, artists began pasting actual bits of newspaper, wallpaper, and colored paper upon the shapes and planes of the painting, often drawing over them with ink, crayon, or paint. These compositions became known as paper collages. Later, artists attached sand, fabric, glass, oilcloth, and the like, which became the beginning of a new art form, the collage. When articles of the real world became a

part of the artificial world of pictures, the collage concept grew into the assemblages and constructions of some of today's art.

Cubism became one of the major art movements of this century, and for an art that was dubbed with an ironic name—it is not made of cubes—it has affected the thinking of many generations of artists.

About the same time cubism was being worked out in France, several artists in Germany were doing important work with new concepts and experimental art forms, especially with expressionistic qualities of the visual image. Wassily Kandinsky, a Russian artist working in Germany, thought of colors as related to tones of music, believing the viewer could respond directly to colors without having to see colored images of recognizable objects. In other words, the feeling of nature could be communicated from a painting without having to use a representational image of the world around us. The visual language of color, line, texture, and shape could stand on its own qualities without realistic images, and abstract images could express thoughts and feelings to the viewer. To help the viewer avoid falling into the trap of looking for hidden images on his canvases, he usually titled his canvases like the illustration, *Panel (3)*.

During the same era, some American artists, such as Stuart Davis, Elie Nadelman, John Marin, Georgia O'Keeffe and others were pioneering with abstract art. Later, the depression years of the thirties and war years of the forties proved to become very productive years in American art.

Federal Art Projects sponsored by the national government provided artists with commissions, support-

ing them during the economic depression, but most important, the federal program allowed artistic freedom and independent expression. The United States government, in supporting art projects and encouraging art activities throughout the nation, created an artistically favorable climate for the growth of new thinking in art.

On the other hand, unfavorable conditions in Europe caused leading artists to immigrate to America. An influx of artists, such as Hans Hofmann, art leaders of The Bauhaus in Germany, leading artists from Paris, and artists connected with the surrealist movement brought new, stimulating ideas and new influences to the active American art scene.

By the middle of the century, the first truly American art movement of world-wide importance was in full swing. The art centers of the Western world had moved from Europe to the United States. Americans were becoming leaders in art, and today, several decades later, the contemporary art scene continues with many American artists leading the way.

PART II
THE
ARTIST
AT
WORK

Materials

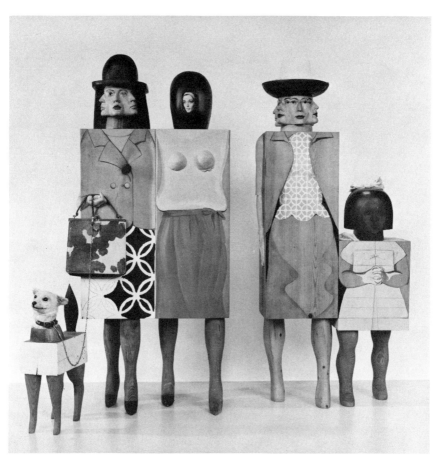

Marisol. *Women and Dog*, 1964. Wood, plaster, synthetic polymer
paint and miscellaneous items, 72 X 82 X 16 in. Collection, Whit-
ney Museum of American Art, gift of the Friends of the Whitney
Museum of American Art. Photograph by Geoffrey Clements.

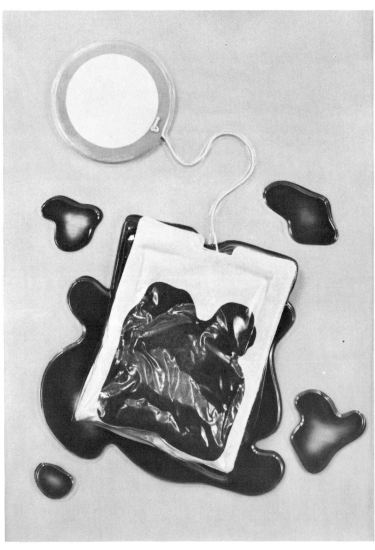

Claes Oldenburg. *Teabag,* from the series *Four on Plexiglass,* 1966.
Serigraph, printed in red, brown and silver on felt, clear plexi-
glass and white plastic, with a felt bag and rayon cord encased,
39⁵/₁₆ X 28¹/₁₆ X 3 in. Collection, The Museum of Modern Art,
New York, gift of Lester Avnet.

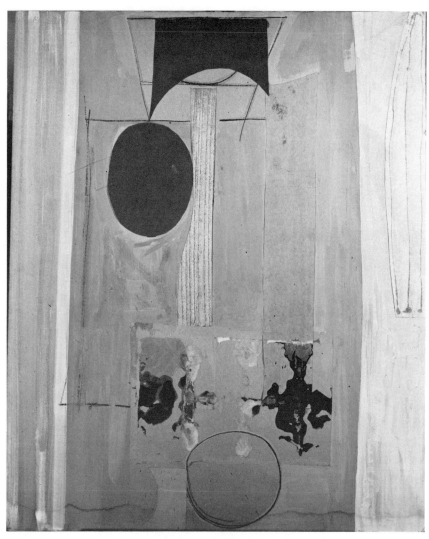

Robert Motherwell. *Mallarme's Swan, 1944*. Collage using gouache, crayons and paper on cardboard, 43½ X 35½ in. Contemporary Collection of The Cleveland Museum of Art.

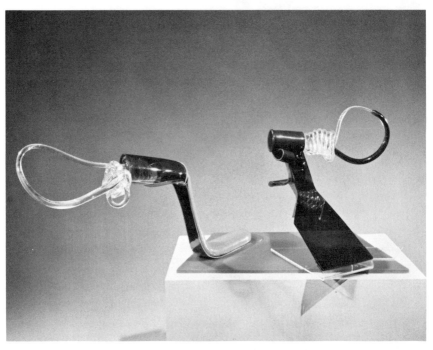

David Weinrib. *Double Loops,* 1965. Plastic and wood, 18½ X 41 X 21 in. Collection, Walker Art Center, Minneapolis, gift of Mr. and Mrs. Howard Wise, New York. Photograph by Eric Sutherland.

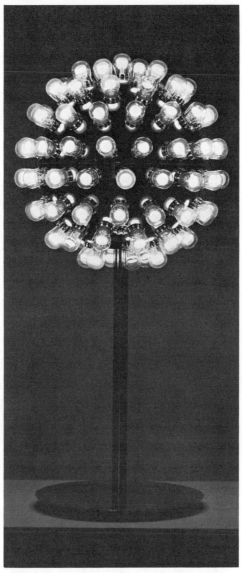

Otto Piene. *Electric Flower*, 1967. Aluminum globe, 100 pro-
grammed lights, 39 in. high X 16 in. diameter. Collection, Walker
Art Center, Minneapolis, gift of Northern States Power Co.
Photograph by Eric Sutherland.

Alan Shepp. *Untitled*, 1967–68. Neon, fluorescent plexiglass, 3 units: 11^{1}/$_{2}$ X 41^{1}/$_{4}$ X 11^{1}/$_{2}$ in., 11^{1}/$_{2}$ X 33 X 11^{1}/$_{2}$ in., 11^{1}/$_{2}$ X 25 X 11^{1}/$_{2}$ in., each side of right angle. Collection, Walker Art Center, Minneapolis, gift of Northern States Power Co. Photograph by Eric Sutherland.

David Smith. *Hudson River Landscape*, 1951. Steel, 75 in. long. Collection, Whitney Museum of American Art. Photograph by Geoffrey Clements.

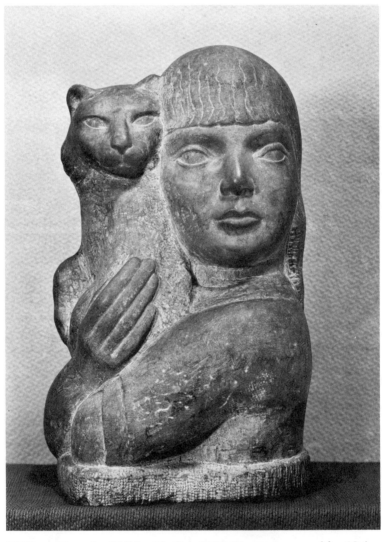

William Zorach. *Child with Cat*, 1926. Tennessee marble, 18 in. high X 6⅝ X 10 in. at base. Collection, The Museum of Modern Art, New York, gift of Mr. and Mrs. Sam A. Lewisohn.

Naum Gabo. *Linear Construction No. 4, in Black and Gray,* 1953. Aluminum and stainless steel, 33 X 27½ in. Courtesy of the Art Institute of Chicago.

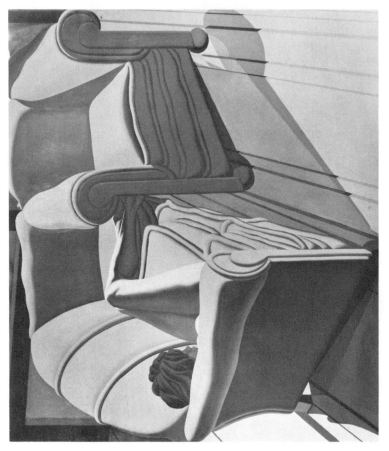

Jack Beal. *Nude on Sofa with Red Chair*, 1968. Oil, 70 X 78 in. Collection, Walker Art Center, Minneapolis, purchased with matching grant from Museum Purchase Plan/National Endowment for the Arts. Photograph by Eric Pollitzer.

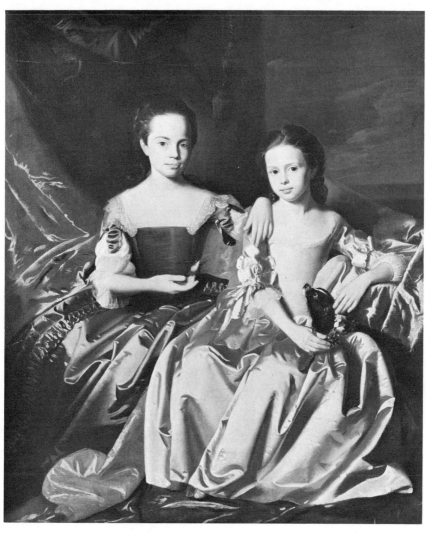

John Singleton Copley. *Mary and Elizabeth Royall, c. 1758. Oil, 57½ X 48 in. Courtesy, Museum of Fine Arts, Boston, Julia Knight Fox Fund.*

Charles E. Burchfield. *Church Bells Ringing, Rainy Winter Night,*
1917. Watercolor on paper, 30 X 19 in. The Cleveland Museum of
Art, gift of Mrs. Louise M. Dunn in memory of Henry G. Keller.

Andrew Wyeth. *Groundhog Day*, 1959. Egg tempera on panel-
board, 31 X 31³/₄ in. Philadelphia Museum of Art, gift of Henry F.
DuPont and Mrs. John Wintersteen.

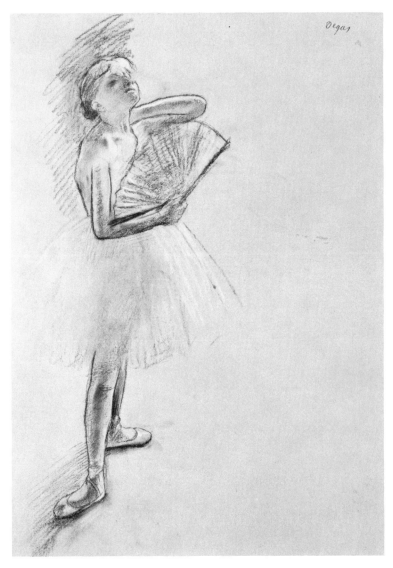

Edgar Degas. *Dancer with Fan, 1890-95*. Pastel on green paper, 24 X 16^1/$_2$ in. The Metropolitan Museum of Art, bequest of Mrs. H. O. Havemeyer, the H. O. Havemeyer Collection.

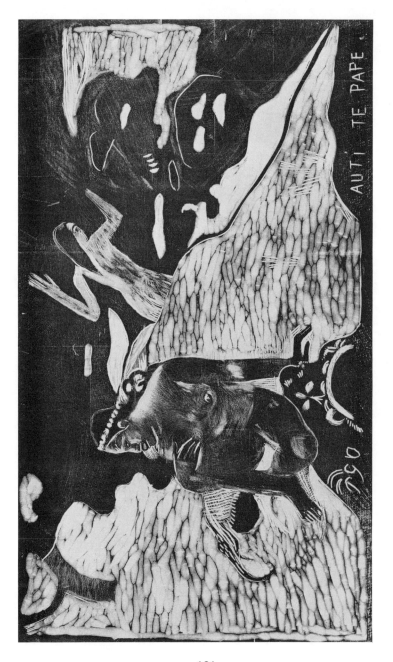

Paul Gauguin. *Auti Te Pape (Women at the River)*, 1894. Woodcut, 8 X 14 in. The Metropolitan Museum of Art, Rogers Fund.

Mauricio Lasansky. *Oriental Image*, 1969. Color intaglio, 76³/₈ X 25³/₈ in. The University of Iowa Museum of Art, gift of Dr. and Mrs. Webster G. Gelman.

102

Wassily Kandinsky. *Composition with Chess-Board "Orange,"* 1923.
Color lithograph, 16 X 15 in. Philadelphia Museum of Art, The
Louise and Walter Arensberg Collection.

4

Materials

"**N**uts and bolts? Barbed wire? Never thought of using a light bulb. What kind of paint is that? What keeps that sculpture from toppling over? Wonder how he attached metal to the canvas? Who would have thought of using plastic spoons?" Viewers as well as professional artists are curious about art materials and techniques, especially in contemporary art exhibits.

Nearly everyone is interested in watching an artist at work, inquisitive about how materials are used to create artwork. Large crowds gather to watch art demonstrations during art fairs and festivals. Students enrolled in art courses are fascinated and excited when exploring the possibilities of a material: experimentation, anticipation, challenging potentials, discovering new techniques are stimulating experiences.

Sometimes surprising, occasionally disappointing or frustrating, yet very exciting and satisfying results are often in store for those working with imagination and creative vision.

Today's artists are skilled jacks-of-all-trades—welders, electricians, carpenters, painters, as well as designers of pleasing aesthetic forms. Tremendous choices of media, using the new materials of twentieth century technology, as well as traditional materials, are available.

From feathers to macaroni, plastic foam or neon signs, synthetics to stainless steel, contemporary art reflects the world of consumer goods; it uses synthetic products and raw materials of industry, found objects, discards from the scrap heap, or objects from the natural world.

Because of freedom of experimentation and expression, the horizons for contemporary artwork are constantly expanding. No doubt, future artists will find exciting and new possibilities for the present day materials that have not occurred to those working now.

In addition to new materials, traditional media are used with new concepts, as combining or attaching found objects to an oil painting or assembling wood into sculptural forms instead of carving or chipping the wood into a sculpture. Marisol's *Women and Dog* is a combination of wood, plaster, synthetic polymer paint and miscellaneous items combined into a sculpture environment.

Sometimes new products renew interest in older art forms. Epoxy resins have revived interest in stained glass windows, the epoxy acting as the opaque material for "leading" the colored glass.

Every artist searches for the medium that best suits his artistic temperament, the most effective means of expressing his visual message. Nearly all explore and experiment with many materials; some choose to work with one or two materials in depth to find the potential and limitations, often feeling a deep emotional involvement with the media; others become quite versatile with many. Picasso was extremely involved and talented with various techniques—painting, printmaking, sculpture, ceramics, textiles. Claes Oldenburg uses many kinds of materials. *Teabag* is a silk-screen process, combining objects and plastic into a three-dimensional collage print. In sculpture to be viewed in the round, Oldenburg uses many varieties of materials which have resulted from twentieth century technology.

The plastic industry has much to offer artists in every field, for painters, sculptors, architects, craftsmen. Synthetic paints have been the most dramatic invention for the painter since the discovery of oil paints several centuries ago.

Synthetic paints, or polymer emulsions, are made by combining plastic resins with pigments. Major advantages of the medium are exceptional adhesiveness and fast drying. The colors are pure and bright, retaining their brilliance, and they have excellent covering power, along with a vast range of choices. Tests for durability have proven to be satisfactory. Acrylic paints are easy to manipulate, using ordinary housepainting brushes or rollers. Water is used for thinning and cleanup, a definite advantage in many cases.

Many varied effects can be achieved with synthetic paint, from transparent washes to thick, opaque

impastos. The finish can be smooth, textured, matte, or glossy. The final painting may look like a watercolor, tempera, or oil. Frank Stella's *Damascus Gate Stretch Variation* (p. 39) is acrylic on canvas. Many contemporary artists choose to work with synthetic media, finding them very suitable for their artistic expression.

Because plastic paints and glues can be applied to nearly any surface, collages, photomontages, and assemblages are adaptable to the media. Epoxy is a strong adhesive for combining three-dimensional materials such as metal, glass, wood, and it is also a paint product. Acrylic polymer medium is an excellent adhesive for paper and cloth, resulting in collages becoming a very popular form of expression, using endless varieties of materials. Robert Motherwell's *Mallarme's Swan* is a small collage of mixed media.

Plastic materials are unique in having physical characteristics of liquid, putty, or solid form. For example, acrylics are available in liquid form as paint, glue, gesso, varnishes; in putty form for molding; solid form as tubes, rods, blocks, or sheets. Various forms of polyester resins are used for either laminating or casting. Plastic foam can be carved or shredded, or used for molds. Vinyls come in flexible sheets for sculptural forms, or liquid inks, transparent or opaque. Oldenburg's *Teabag* exemplifies some of the versatile qualities of plastics.

Artists take advantage of the transparent and reflecting qualities and the molding possibilities of plastics to create optically shimmering or kinetic effects, constantly changing as the viewer moves in front of the artwork. And luminous colored acrylic sheets can be laminated together, resulting in lucid colors of un-

usual depth and brilliance. Aesthetic inventiveness with plastic materials is continually expanding, because artists are interested in scientific research and developments of technology.

Electric light bulbs, neon lights, ultraviolet, infrared, or fluorescent lights are attached, hidden, combined, or used as spot lights. Neon lights are bent into sculptural shapes or into suspended forms.

Motors are attached to move shapes and contraptions, to cause forms to whirl, blink, flash, clink, or clack, to start or to stop.

The materials of the machine age are compatible to express all ideas of our times. Metal sculpture uses the metals, raw materials and equipment of industry. The potential of metals is limited only by the characteristic of each metal. Sculptors such as David Smith helped establish new concepts for uses of metal in artwork. *Hudson River Landscape* is welded steel in an open, thin, airy design, quite different from earlier sculpture of metal casting.

Traditionally, sculptors worked with stone, wood, or cast metal. The subtractive method for stone and wood carving, chipping, hammering goes back to ancient days. William Zorach used the subtractive method for *Child with Cat*. Artists like sculptor Henry Moore continue to work with traditional materials and methods, but use new concepts of space and form. The aesthetic appeal of marble and stone, the textures, colors and aroma of wood are as appealing to artists today as they have been for centuries past.

Much of contemporary sculpture is an additive process, the sculptor adding shapes rather than carving away, as David Smith's steel sculpture. Additive

sculpture can combine many kinds of materials. Marisol's sculptures used several, and Naum Gabo's *Linear Construction No. 4 in Black and Gray* is an additive sculpture of aluminum and stainless steel. Machineage sculptors, painters, and architects combine glass and metal, concrete or plastic with metal, wood with metal, canvas with metal, or whatever else is appealing to the artist.

Several kinds of metals are often combined within one form: ferrous and nonferrous, as iron combined with bronze, or steel with copper. Because of the variety of textures and colors, metals enhance one another, as shown in Gabo's sculpture.

Found objects and discards assembled into three-dimensional forms, such as Louise Nevelson's *Sky Cathedral Presence* (p. 41); junked automobile parts, scraps from junkyards, farm machinery, industrial scrap piles, throwaways from every conceivable material can be turned into art forms by imaginative artists. Picasso made a sculpture of a bull using the handlebars and seat of a bicycle.

Those concerned with our environment recycle man-made materials into social satires; others use natural materials from the world as an expression for the love and beauty of nature.

The list of materials available to the twentieth century artists seems limitless and never-ending. During this age it isn't always easy to determine the materials used in artwork. A century ago artists were held to only a few: sculptors worked with three main materials—stone, wood, or cast metal; painters were limited to about six painting techniques—oils, tempera, fresco, watercolor, encaustic, and pastels. At various times in

history, one medium was more popular than another, but oil paints have been a favorite for many centuries and continue to be so. Artists today find the tactile qualities, the viscosity, and the ease of blending oil paints as appealing as the painters of the days of Rembrandt.

Jack Beal's *Nude on a Sofa with Red Chair*, a photorealist interpretation, is an example of a contemporary artist using oil paints to their best advantage.

Portrait painters of the last century became very skillful in imitating realism, utilizing the blending qualities of oils to create textural copies of cloth, hair, skin. John Singleton Copley's *Mary and Elizabeth Royall* is a dramatic painting of textures and realism. Oil painting may appear smooth with invisible brush strokes, and a porcelain-like finish, or use thick, prominent strokes, with masses of paint piled on with a knife.

Several techniques are possible with oils. Tempera or acrylic underpaintings may be covered with thin glazes of transparent oil colors, producing a painting of inner glowing colors. Or the underpainting may serve as a foundation for thick, textured oils.

Often painters choose to paint with oil paints in a direct, wet-in-wet technique, a speedier method called alla prima painting. In skilled hands, the final paintings appear fresh and spontaneous, but beginners sometimes become discouraged with muddy results.

The choice of colors and range of values with oils are extensive, but undoubtedly the most outstanding advantage of the medium is the wide acceptance by artists and the public.

Watercolors, like oil paints, continue as a popular

medium. Artists in the Far East have developed water-color into a highly artistic, sensuous art expression; the medium is a natural for their brush technique and art concepts. The atmospheric, poetic qualities of water-colors appeal to many artists as an expressive, ver-satile painting medium. Watercolors respond to many ways of painting, and, because of their transparency, the kind of paper used plays an important part in the final effect.

Watercolor combines well with other media, often used in combination with ink, pastels, crayon or gouache. Gouache is watercolor mixed with white pig-ment and a binding agent, as gum arabic, to make it opaque rather than transparent. It is sometimes used to accent drawings or transparent watercolor paint-ings. Motherwell's collage has gouache combined with other materials. Acrylic paints can be used as water-colors or gouache.

Andrew Wyeth and some other artists choose to work with egg tempera, a very old technique used be-fore the invention of oil paints. Tempera paints today often refer to any opaque paint soluble in water, but traditional tempera was a technique of mixing pig-ment with egg, milk, or vegetable gums. The egg or gum acts as a binding agent to "temper" the pigments, making them workable. Synthetic paints, presenting fewer problems, can be used to give somewhat the ef-fects of egg tempera.

Traditional egg tempera results in brilliant colors of a translucent freshness. Tempera paintings several hundred years old still retain their luminosity and brilliance. Andrew Wyeth's *Groundhog Day* is a mod-ern example of the slow, methodical process, which

requires careful drawing and small brush strokes of painting for shading, blending, and overpainting colors. Egg tempera does not lend itself to large paintings or the work of the occasional Sunday painter.

Another ancient painting technique used by some contemporary painters is encaustic painting. Jasper John's *Tennyson* is encaustic and collage. Encaustic medium combines pigments and hot wax. Coloring matter for pigments used in all paints come from many sources, minerals, organic materials, and chemical combinations. They are finely ground and mixed with a binder, in this case, hot wax. The pigment-wax mixtures must be kept a specific temperature or they will separate. After the colors are applied, they must be blended with heat, and a final heating is then passed over the surface. The final art work is worth the effort because of the unusually lustrous finish, sometimes resembling that of semiprecious stones. Some excellent examples, many centuries old, are preserved in museums.

Another very old painting technique is fresco painting. Sometimes the term "fresco" is loosely used when referring to any wall painting, but it should not be confused with murals which are painted or attached to finished walls. True fresco painting actually becomes a part of the wall. The artist mixes pigments with water, usually lime, and applies the paint mixture to fresh wet plaster, the paint sinking into the plaster, becoming a part of the wall. Michelangelo used the true fresco technique in the Sistine Chapel in Rome. Fresco painting takes much planning, since the artist must complete an area in one work period with the fresh plaster. Wherever he stops, if there is plaster

left, he must cut it away, because it cannot be accurately matched later; since a line will show where the next section begins, the artist must carefully plan the design, using the break where it will be the least conspicuous. True fresco is a challenge, and not much used today, but the possibilities with the process have not been exhausted.

Pastels and chalks continue as drawing-painting media for today's artists, but the major disadvantage is that the particles of nearly pure pigment lie loosely on the surface of the paper. The artists must use a fixative or cover the art work with glass or plastic. The velvet, shimmering haze of pastels appeals to many portrait artists. Mary Cassatt and Edgar Degas gave the medium new life with their paintings of the theater and ballet dancers. Edgar Degas' *Dancer with Fan* is an example of his concept of using pastels as a direct drawing technique rather than the traditional blending technique.

Oil crayon and felt tip pens are another direct, spontaneous drawing-painting material, often chosen for on-the-spot paintings and drawings or in combination with other media.

Printmaking, or graphic art, is another area in which materials and methods have come a long way. Prints, or graphics, are not reproductions like illustrations in a book, but they are impressions made from an original printmaking process, duplicated in multiples. Because prints are made in an edition of multiple originals, the number of duplicated impressions permits many people to buy original art work.

Printmaking methods can be very simple or quite complex. No longer are prints only small black and

white impressions. Today's printmaking techniques and imaginative use of materials stagger the imagination, nearly defying any listing of the materials or processes.

Basically, there are four printmaking processess: relief, intaglio, lithography, and stencil.

Nearly every school child has made a woodcut or linoleum block print, which are relief printing methods; the raised surface prints and the cut-away section do not. Woodcuts are one of the oldest forms of printmaking and a popular graphic art today. Strong shapes and texture of the wood are typical of the process, as can be noted in the Gauguin illustration, *Auti Te Pape* (Women at the River). Picasso used common linoleum to create a large series of multicolored relief prints in the late fifties and early sixties.

Intaglio printing, engravings or etchings, are impressions from indented or recessed areas made on metal plates or plastic materials. The design is scratched into the surface for drypoint; the lines are removed with a v-shaped tool in an engraving; an etching uses acid to indent the design. The ink comes from below the surface in intaglio processes and from raised surfaces in relief printing. Mauricio Lasansky's *Oriental Image* is a color intaglio.

On the other hand, lithography is a surface printing process based upon the antipathy between grease and water. A drawing is made with grease upon a surface —stone, zinc, or aluminum plate—and treated with chemicals. When ready for printing, the grease image accepts the greasy ink and the undrawn wet areas repel the ink. Kandinsky's *Composition with Chess-Board "Orange"* is a color lithograph.

In the stencil process (serigraphy or silk screen), the print is obtained by forcing the ink through open areas of a design which are not blocked out by stencil shapes. With the use of several stencil screens, many colors can be used.

Because of their popularity, graphic exhibits are placed in shopping centers, supermarkets, and department stores in addition to exhibits in galleries and museums. Thus, the interested viewer is provided excellent opportunities to examine many kinds of today's innovative graphic art imagery.

Art viewers and collectors do not need a technical knowledge of art materials or techniques to appreciate art, but if the viewer has some knowledge of the ways and means of art expression, he may develop a deeper understanding of the problems the artist solved while producing the art form. And by knowing something of art media and techniques, a natural curiosity is satisfied concerning the characteristics of a finished painting, sculpture, print, craft, or combined art form.

The person who limits his art viewing to reproductions in books and has never seen original artwork may never become curious about materials, because art materials look more or less the same when reproduced as illustrations on paper. For example, with a painting, the fluid brush strokes, the satiny smoothness of some areas, the dry crumbliness appearance of scumbled* areas, and the rich texture of paint strokes are lost in a reproduction.

When looking at an illustration of a large wall

*A technique where opaque paint of a different color is dragged over a dry color area and some of the underlying color shows through.

mural or a gigantic mural-size painting, the viewer misses the experience of the artwork because the reproduction appears more like a small painting. By the same token, the effect of Jackson Pollock's or Mark Rothko's art is lost on the viewer in a reproduction. In a photograph of sculpture, the visual-textural effect of the material is completely lost in the transposing from one media to the other, much "like kissing your sweetheart through a handkerchief."

In discussing materials, it is important to stress again the fact that it is the artist who is the visionary: materials and techniques do not make the art form; they are the means for expressing what the artist has to say.

5

Color

Color—beautiful, vibrating, eye-teasing, luscious, bold, wild, torrid color—surrounds us everywhere. The enjoyment of color is one of life's most pleasing experiences.

Artists have had a special love affair with color for about a hundred years, beginning with the impressionist painters; but only in the past few years have a majority of people accepted the color thinking of the art world. Color innovations and color experimentation are no longer viewed as visual insults.

Not many decades ago, most people considered bright, bold colors too gaudy, barbaric for refined taste. Muted colors, tans, browns, and grays were the accepted colors. Social customs dictated specific colors for certain purposes and occasions. Black was the color for funerals, widows, clothing for the elderly, and also

119

for automobiles. Color thinking dictated light blue for baby boys and pink for baby girls, and nice ladies never wore red. Color thinking restricted color usage to a few conventional schemes. Many color combinations were considered unusable or clashing; blue couldn't be used with green, red with pink or purple, orange with green, and so on.

Why the change in attitude toward color? Art has certainly had a great influence. Op art, pop art, neon light art, psychedelic art, and colorful graphic art surround us in our daily life. Many young adults, especially those who have had some art courses, are quite sophisticated with color.

In addition to the artists' visionary concepts with color, advances in color technology have provided both artists and industry with better pigments and dyes. New paints, such as polymers and acrylics, fluorescent paints, excellent quality enamels and lacquers, are available in a wide range of brilliant and vivid colors.

Our world has become very colorful, and omnipresent color bombards our senses. Color television and movies, colorful billboards, advertising posters, and consumer goods are panoramas of color. Merchandisers know how to use color to sell products, the colors that attract buyers. The shelves in the stores are colorful displays, each product designed with color to catch the eye of the consumer. Patches and swaths of color are a part of our everyday world; it is nearly impossible to be indifferent to color.

We have become more tolerant toward unconventional color, extreme color thinking; bold, blazing colors are no longer considered shocking. Wild color

combinations are not cause for heated debates or issues of visual traumatic experiences. Now masses of people have an opportunity to exercise personal freedom and choices with colors. A new awareness and sensitivity toward color are prevalent in our culture.

Because color is a very powerful and obvious element around us, those with normal eyesight feel the emotional effect of it. Can you imagine successfully describing a color to a blind person without referring to human emotional responses or the physical properties we attach to color? Could you describe red without using such words as fire, hot, warm, sun?

Our everyday speech is sprinkled with color descriptions like purple with rage, green with envy, a yellow streak. Writers and poets are very much aware of the power of color words to create moods and intensify images.

Most of our associations with color begin when we are children, and our color attachments and preferences are influenced by the colors in our environment. Attitudes toward color and color thinking are reflected in our customs.

In our culture, most brides choose traditional white for wedding gowns, and red is the color for valentine candy boxes. Would you react to receiving a black and yellow valentine or seeing a bride dressed for her wedding in a black bridal gown and veil?

Color thinking is associated with weather conditions; time of the year or day; a specific place, like the beach or mountains; and with our moods. Emotional reaction to colors and color association have been passed down to us. Early man connected magic powers with color; certain hues were used in rituals, and

specific colors were thought to have power to ward off evil spirits. Some of these color concepts continue today in some societies.

The ancient cities of Greece and Rome were richly decorated with many colors. Bright colors enriched their architecture, sculpture, murals, and frescoes. The painted sculpture often had jewels for eyes and decoration.

Artisans of the Middle Ages created brilliant, glowing stained glass windows; gleaming jewel-like mosaics; vivid paintings of tempera, gold leaf and encaustics; woven tapestries of rich and varied hues.

During the Renaissance, color thinking in art became concerned with matching or imitating the colors of nature; color was used to create the illusion of depth and space with light and dark color patterns. The wealthy surrounded themselves with rich and vivid colors in clothing, jewels, and furnishings, but the poor man's world was quite drab.

In early American history, color did not play a very large role in the life of the average person. After the accumulation of wealth and the invention of new and better dyes and pigments, more of the population could indulge in the human passion for color in their everyday world.

Intense color experimentation and innovations started with the impressionists and painters such as Van Gogh, Gauguin, Matisse, Kandinsky, and Cezanne. Psychologists have become interested in how people respond to color, why we have strong likes and dislikes toward specific colors, how each color seems to speak to us with a voice of its own, and why we think of some colors as hot and others as cold.

Artists are especially aware of human responses to

color, since they are creating art for people to see and enjoy or respond to with some specific reaction. Some painters think of their palette of pigments as the musical instruments of a visual orchestra and the artist as the composer and conductor. Each artist uses color in his own unique style; some prefer bold, bright, clashing canvases of great color contrasts; others may prefer quiet hues, subdued, soft and muted.

Cezanne once remarked, "Light does not exist for the painter." He was referring to the fact that the artist paints with pigments and has results different from the physicist who is working with light rays. Each has different substances and theories with which to work. Unless the artist is "painting" with colored lights, he is not working with scientific theories of color. Pigments do not combine like the colors of light rays. With light waves, all colors combine to make white light. In pigments, all colors combined theoretically result in black, but the combination can result in a muddy hue of black. Of course, in order for our eyes to perceive color, we must have light, since we cannot see colors in absolute darkness.

How does the artist learn to use this powerful element, color? The study and use of color are important areas for the painter; the possibilities are vast, and the artist can spend a lifetime experimenting and designing with color. No wonder some artists live such long lives, for there is much to learn and discover in art! A lifetime is hardly long enough.

A general knowledge of color mixing is necessary, but many artists are not as concerned with color theories and color systems as they are with the many color possibilities.

Some artists make careful color studies before start-

ing the final painting; others choose to work directly upon the canvas, following their intuition, letting instinct lead the way into the painting, solving the color problems. Color is a complex area, and as the painter works, studies, and experiments with these complexities, he becomes more aware of the results and surprises color has in store for him. Ultimately, his artwork will depend upon his experiences with color, and his choices will often be guided by intuition and imagination. Above all, it probably will be his attitude and color thinking that will influence his final choices.

Painters learned long ago of the illusionistic qualities of colors. Warm colors like red, yellow, and orange appear to advance, and cool colors like blue, violet, blue-green, and black appear to recede. Weakened colors and grayed colors with blurred edges create the illusion of distance. But rules about color, like all rules applied to art, are only general and can be broken. Actually, because of the effect of one color upon its surrounding colors, working with color often becomes a process of color adjusting rather than color mixing. For example, red placed next to green will appear redder, and the green will appear greener. Also, a red will appear more vivid or brilliant if it is surrounded by a dull green. One color complements or enhances the other. Artists call the red-green, or orange-blue, or yellow-violet combination *complements*. Yet, these colors dull each other when mixed together. A bright blue can be changed to a dull blue by adding a few drops of orange. If too much orange is added a dull brown or gray is the result. With experimentation, the painter learns how to use complemen-

tary colors, because they are very important for both the contrast and vibrant qualities and their mixing qualities.

Op artists rely upon a fool-the-eye illusionism, using the vibrating qualities of the complements. The side by side color contrasts and the geometric lines and shapes create the eye-teasing sensations of optical art. Because of the brilliant contrast of the complementary colors, the large mural-size paintings of Larry Poons give the viewer the sensations of dots and ellipses moving about on the canvas.

Van Gogh liked using complementary color schemes in his easel-size paintings. He was especially fond of the blue-yellow-orange combination. Because Van Gogh also liked texture, he seldom applied paint to the canvas in the conventional manner. Often he painted with a knife, as well as a brush; sometimes, directly from the tube; and at other times, with a stick or his fingers.

Hue, value, and intensity are three aspects of color, each having a particular quality. Hue refers to the properties of a color that enable us to give it a name, such as the color blue. Actually, hue may suggest some modification of a color as, "The brilliant red was changed to a less vivid hue."

Value refers to the lightness or darkness of a hue. A color low in value is a dark hue, sometimes called a shade; and a color high in value is a light hue, or a tint. Unless the painter is using transparent watercolor, he will use black or gray to darken or lower the value of the color and white to lighten or raise the value of the color. Water is used to lighten the hue in watercolor. Modification of a color with black, white, or gray may

be referred to as the *tone* of a color, such as a light tone of green. Our eyes are very sensitive to these gradations or nuances of a hue. For this reason a monochromatic painting can have many gradations of a color, and dullness and brightness. In nature, many birds are examples of monochromatic colors—such as a robin or a bluejay.

When Picasso painted early in the century, his blue and rose periods of painting were basically monochromes in which he used one color with many shades and tints, and, in addition, black and white. Other artists, working with the phenomena of color have painted with monochromatic color. Ad Reinhardt in his *Black* paintings kept the shades of the hues to the very minimum, with subtle gradation and delicate transition, close in values. In reproduction, this type of painting loses much of the visual effect.

Intensity refers to the brightness or dullness of the color. When the value of a color is changed, the intensity or saturation of the hue is also changed. Intensity, or chroma, can be changed by adding white, gray, black, or the complement of the color.

Because of the color-sensitive response of our eyes to minute or delicate changes within a color, the range from light to dark, from dull to bright is almost unlimited.

In theory, there are three primary colors: red, yellow, and blue. The three primaries plus black and white are theoretically supposed to produce all of the rest of the colors. Should the artist limit his palette to the three primary colors, he knows that he will need at the very minimum two hues of each. The basic reds needed are a warm red (cadmium red medium), which

leans toward yellow, and a cool red (alizarin crimson), leaning toward blue. This is also true of blue and yellow. The artist must have a warm yellow (cadmium yellow medium) and a cool yellow (lemon yellow), and two blues (ultramarine blue and thalo blue). Black and white are also essential in the minimum palette; nevertheless, it is nearly impossible to mix from the listed colors a clear purple or a rich brown.

Black and white pigments are certainly not neutrals as some color systems state, but very powerful colors; both of them are very positive and dominating visual expressions. The greatest visual impact of color contrast is the vibrancy of white next to black. Franz Kline created some outstanding paintings using only black and white. Georges Roualt, realizing the power of black to bring out the brilliance of other hues, outlined shapes of bold colors with thick black lines.

When color becomes important to a painting, it becomes very important. Much of the painting of today is entirely dependent upon color. Usually in nonobjective paintings (those without subject matter) color is placed above all other visual elements, and color dominates the art form.

In addition to the value qualities of a hue, color has transparent, translucent, and opaque qualities; lustrous, irridescent, and metallic qualities. Furthermore, dull, shining, rough, smooth, thick, and thin applications of paint are among the many possible variations. Color combinations and color effects are limitless.

Artists are continuing to find new ways of color expression and color thinking in areas other than pigments. Colored lights and color with film are some of the innovative areas. There is also new thinking with

regard to traditional materials, such as colored glass, mosaics, fabrics and dyes.

Assemblages, junk sculpture, fluorescent light and neon light sculpture, and pop sculpture have explored new color possibilities. Often the color in sculpture is the natural color found in wood, stone, or metal, but many are painted with bright, bold colors.

As an art element, color has become a major creative force in much of the art produced today. Who knows where color thinking, experimenting, and new ideas will lead in the future? The strides made with color in the past fifteen years stagger the imagination for the color possibilities of the twenty-first century.

Line

and

Texture

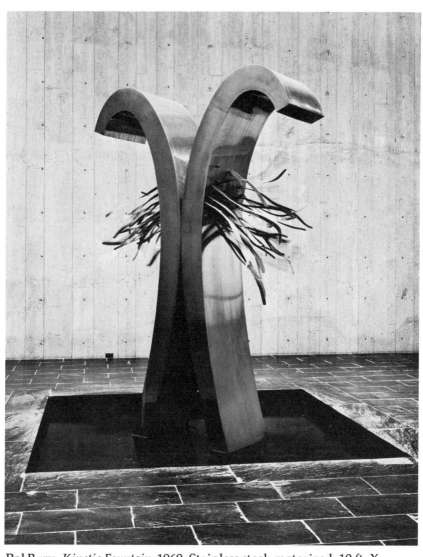

Pol Bury. *Kinetic Fountain*, 1969. Stainless steel, motorized, 10 ft. X 4 in. The University of Iowa Museum of Art, gift of Mr. and Mrs. C. H. Crowe.

John B. Flanagan. *Jonah and the Whale,* 1937. Colored and textured stone, 29¹/₂ X 11 X 3 in. The Minneapolis Institute of Art, The Martha T. Wallace Fund.

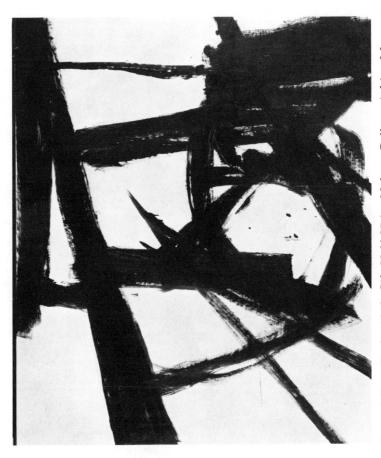

Franz Kline. *Turin*, 1960. Oil, 80 X 95 in. Nelson Gallery-Atkins Museum, gift of Mrs. Alfred B. Clark through the Friends of Art.

Henri de Toulouse-Lautrec. *Alfred La Guigne,* 1884. Gouache on cardboard, 25³/₄ X 19³/₄ in. National Gallery of Art, Washington, Chester Dale Collection.

Paul Gauguin. *Self-Portrait*, 1889. Oil on wood, 31¼ X 20¼ in.
National Gallery of Art, Washington, Chester Dale Collection.

135

Grant Wood. *American Gothic,* 1930. Oil on beaver board, 29⁷/₈ X 24⁷/₈ in. Courtesy of the Art Institute of Chicago.

A diagram of Grant Wood's *American Gothic*. The arrow lines indicate the eye-paths, or implied and actual lines predetermined by the artist to lead the eyes around the composition. The rhythmic movement of the visual passage prevents the formal organization from becoming too static and monotonous.

Cave painting, Spain. Frobenius Collection, Frankfort, Germany.

Johnny, age 9, Colorado. *Boy Skating.*

Rachelle, age 6, Illinois. *Girl on a Box.*

Theresa, age 8, Illinois. *House.*

Igor, age 7, Kiev, Russia. *Wild Horse.*

Paul Klee. *Jörg*, 1924. Watercolor on paper, 9¼ X 11¼ in. Philadelphia Museum of Art, The Louise and Walter Arensberg Collection.

White Horse. Page from *Drawing Book,* c. 1876. Joslyn Art Museum Collection, Omaha, Nebraska, gift of Mrs. J. Barlow Reynolds.

Katsushika Hokusai. *Woman Fixing Her Hair*, early nineteenth century. Brush and ink, 16$\frac{1}{4}$ X 11$\frac{5}{8}$ in. The Metropolitan Museum of Art, gift in memory of Charles Stewart Smith.

An example of an Ancient Egyptian profile head and front-view eye.

An example of an Ancient Egyptian figure standing on a ground
line, and hieroglyphics along with drawing.

147

Henry Moore. *Sketches for Sculpture*, 1939. Black, blue and brown crayon, two pencil notes, 9½ X 16¾ in. Philadelphia Museum of Art, given by Curt Valentin.

Rembrandt van Rijn. *Noah's Ark*, 1659–60. Reed pen with brown ink and brown wash, 7⁷/₈ X 9¹/₂ in. Courtesy of the Art Institute of Chicago.

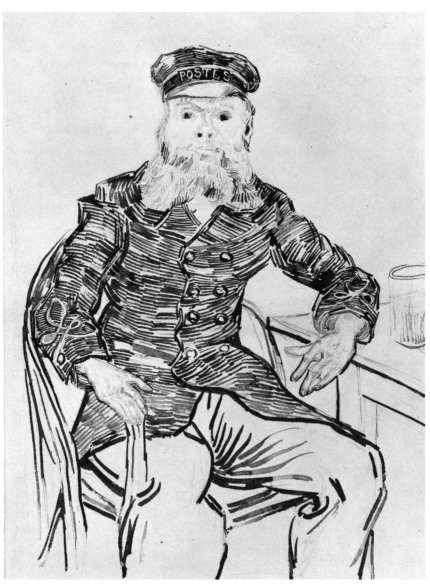

Vincent van Gogh. *The Postman Roulin*, 1888. India ink and black crayon, 23¼ X 17½ in. Los Angeles County Museum of Art, Mr. and Mrs. George Gard De Sylva Collection.

Vincent van Gogh, *Street at Saintes-Maries*, 1888. Brush, reed pen and ink, traces of pencil, 9⅝ X 12½ in. Collection, The Museum of Modern Art, The Abby Aldrich Rockefeller Bequest.

151

6

Line and Texture

L ine is a mark for our eyes to follow. Line is a path for visual tracery, important to all visual art forms. As a visual tool for artists, line is the most direct, the most simple, and the most common means of expression.

Texture is first experienced through our sense of touch. Visually, texture is revealed in the way the surface reflects light. A very smooth, shiny surface reflects a great deal of light; coarse, rocky, or furry surfaces do not reflect as much light since the unevenness breaks up the light, thereby creating shadows.

In nature we are surrounded by a great variety of textures. If we look carefully, these natural textures are a source of pleasure to us. The visual pleasure of viewing texture is an interplay of two senses, touch and sight. Texture and line occur at random in nature,

but in art they are organized with thought and care.

Because line is a common everyday experience in our environment, i.e., on highway signs, fence posts, spider webs, etc., some viewers may not have thought of line as an important visual tool in artwork.

Line is a term with several meanings when used in reference to art forms. Line may refer to the actual mark made with a pen or brush, or it may refer to several linear components used to create a rhythmic pattern of movement for the eyes to follow around a painting, sculpture, or building.

Lines communicate ideas and feelings to us. Thin, graceful lines suggest tender, sensitive feelings; bold thick lines express vigor and strength. The direction of lines suggests emotional qualities. Vertical lines give the impression of strength and dignity, probably because we associate vertical lines with trees, pillars, towers, skyscrapers, etc. Horizontal lines infer a state of calmness or rest, and diagonal lines may indicate a feeling of confusion, action, or excitement.

Line may be expressed in sculpture with actual linear material such as wire, rods, or metal strips. (See p. 93.) In addition, the term *line* may refer to the edges and the rhythmic patterns of the shapes and planes of the sculptural form as a whole—the lines of the form. For example, the lines of Pol Bury's *Kinetic Fountain* are graceful, and the motorized movement of the metal strips create a gentle motion unifying the flowing lines and gleaming texture of the surface. *Jonah and the Whale,* by John B. Flanagan, is textured stone. Line is implied on the outside edge and actual lines are incised within the sculptural form.

Line in architecture defines the character of the

building and the spirit of the concept. Architectural lines are created with combinations of building materials to lead the eyes up or around the structure. The line may be an actual line of color, or contrast of texture in the materials. Or it may be in the lines of the overall structure, such as the tall spires and pointed arches of Gothic architecture. The lines of a Gothic cathedral lead the eyes upward, reflecting medieval man's desire to reach heaven.

The serene, dignified lines of classical buildings have been imitated since they were developed in ancient Greece. The Greek builders were aware of the power of line; they also discovered that line doesn't always appear to the human eye exactly as it is. For example, straight columns appear concave; consequently, the pillars must be slightly bulged. Long, horizontal lines appear to sag in the middle, requiring slight corrections. The Parthenon in Athens, a temple of exquisite proportions, is a splendid example of ancient Greek architecture overcoming the visual phenomena. Lines can create optical illusions in drawing and painting as well as in architecture.

In painting line often plays a dual role, that of actual lines, or linear patterns to create implied lines in the composition. The actual line may be thick, broad strokes of paint expressing vigor and power, as in Franz Kline's *Turin*. Or the artist may paint but a few lines here and there to emphasize an area, outline an edge, or strengthen or define a shape, as in Toulouse-Lautrec's *Alfred La Guigne*. In Paul Gauguin's *Self-Portrait*, thick and thin lines are used to create a path for the eyes to follow around the simplified shapes.

Sometimes painters eliminate actual lines from their

painting by blending or blurring the edges of one shape into the edges and color of the neighboring shapes. Linear patterns or linear perspective also may be used to lead the eyes into the picture plane. And rhythmic movements around the picture plane may be accomplished with implied lines. In the illustration and diagram of Grant Wood's *American Gothic*, notice how linear devices are used to lead the eyes around and into the painting. Contemporary artists often use implied lines in their compositions; however, they feel free to employ actual lines as well, whatever is best for the most effective imagery.

But of all the visual tools of the artist, using lines to create a visual image seems the most natural way for mankind to express thoughts and ideas. How many times have you made a sketch or diagram to explain an idea when a verbal description seemed inadequate? Since drawings depend very much on line, many viewers may feel a deeper attraction to them, as nearly everyone likes to sketch or doodle, and everyone uses a pen or pencil for writing.

The cave drawings and paintings of Stone Age man are convincing evidence that man has innate ability to draw and that line is basic for visual imagery. The illustration of the bison found deep in a cave in Spain is estimated to be at least twenty-five thousand years old! No one knows the purpose for ancient paintings and drawings found in the caves of Spain and France, but many believe they were part of a magic ritual to insure hunting skill and success. Whatever their purpose, they stand as visual proof of mankind's instinctive ability to draw.

Also, children take great delight in drawing, and are uninhibited in creating pictures to express their thoughts. The ability to communicate with drawings seems as instinctive to a child as his ability to talk. Children's drawings are unique, charming, and appealing in their simplicity and directness. Often, because of a limited vocabulary, younger children may express their feelings more clearly with drawings than with words.

Children draw with line, outlining shapes, separating them from the background, using the same style with brush and paint as they do with chalk, crayon, or pencil. Seldom is any shading used, nor is there concern for roundness of objects, or deep space on the picture plane.

The very young child goes through a scribble stage until about school age, when he begins to draw abstract symbols for objects. For example, images resembling lollypops are symbols for trees. The children's drawings of a house or a person, as in the illustrations, are nearly universal symbols for children everywhere.

Strange as it seems, children around the world use line in their artwork in much the same style during specific stages of maturity. In other words, the child in the United States draws in much the same style as the child in Russia.

Older children, about age eleven or twelve, become disenchanted with symbol drawing; instead, they want to draw realistic-appearing images, becoming concerned with proportion, color, shape, space, and depth. This is an age when the opportunity to view all kinds of artwork from all cultures and periods of

history is exceptionally valuable. Otherwise the child is apt to become completely discouraged with his own artwork, giving up drawing altogether.

Children's drawings are exquisite expressions of childhood. Unfortunately, some parents do not appreciate visual forms of expression. Those who ignore their children's art or give the child the impression his artwork is worthless are unconsciously reflecting their values toward art as a whole. Consequently, the child will probably perceive art as an unimportant or worthless form of expression and a meaningless, time-wasting activity.

Admiring the direct appeal and honest expression of childhood art, some artists, as Paul Klee, have deliberately made childlike, fantasy drawings. Seldom can adult artists recapture in art form the honest expression and naive charm of children's art; Klee's *Jörg* has the appeal of a child's drawing, yet incorporates a visually sophisticated comment of adult pathos.

The viewer who has a preconceived notion about drawing as an art form probably will not respond with much interest to work such as Klee's. But the more art and the more drawing the viewer sees, the more he realizes that art can be expressed in countless different ways.

Because of the diversity of contemporary drawings and the opportunity to see art from many cultures, interested art viewers are aware of the boundless, varied styles in which art can be expressed. For example, the beautifully expressive drawing by White Horse, a native American, is appreciated by a wider viewing audience today than it was when drawing concepts were held within more rigid modes of traditional methods.

The drawing in the illustration is from a book of drawings White Horse made while in prison in the 1870s. The book was taken to the Philadelphia World's Fair in 1876 and later donated to the Joslyn Art Museum in Omaha.

Oriental painters have always recognized line as an important element in painting. The rhythm, the economy of line, and the sensitive expressiveness of each brush stroke of Oriental art have been admired by many Western artists, especially during this century when line became more important again in Western painting.

Oriental art, ancient and medieval art of Europe, children's art everywhere, primitive art, ancient Egyptian art, and much of twentieth century art all have two factors in common: they use line as an important element to outline shapes; and they do not apply artificial rules, such as linear perspective, to create the illusion of deep space in their drawings and paintings.

On the ancient walls of Egyptian tomb paintings, a single deliberate line was used to outline the subjects, delineating the shapes from a background. Color was often used inside the lines to enhance the design, but color was of secondary importance to their line drawing. The Egyptian artists placed their figures on a ground line in order to depict sequences of events and illustrate a span of time in their picture stories. If the drawings of people appear strange to our eyes, it is because the Egyptian artists were restricted in their art with drawing rules dictated by the priests and handed down from generation to generation. The head is shown in profile with a drawing of a front-view eye;

the shoulders to the waist are front view, but the body twists in an unnatural position to a profile view from the waist to the ground line. Hieroglyphics were also used as a part of the story-telling pictures, because life on earth was illustrated for the gods in preparation for a continuous afterlife. Although Egyptian artists had rules for drawing man, apparently they were more free to draw animals and nature. Certainly some of the Egyptian animal art and nature paintings must have inspired artists for centuries.

Because drawing is a spontaneous and direct art medium, many kinds of drawings exist on many levels — from quick sketches or diagrams to finished ready-to-frame artwork.

Many artists make working drawings to be transposed into other art forms, much like the example of the sketches by the well-known British sculptor, Henry Moore. Usually, artists keep sketch books filled with drawings ranging from symbols and partial sketches to completed sophisticated drawings. Most consider a sketchbook a visual diary, a personal storehouse of visual imagery.

Rembrandt's drawings, many of which he considered studies, are brilliant renderings, showing the touch of his genius. With but a few strokes of a pen or brush, he could make a completed drawing. The bulk of his drawings were made with pen, brush and brown ink. Sometimes he diluted the ink with water, using it as a wash, painting in the darker areas of the drawing. He did not limit himself to one technique, but experimented with other drawing media. His drawing ability and sensitivity with line enabled him to create some of the greatest etchings of all times.

Line is very important in some printmaking processes. Lines are cut into surfaces of wood or linoleum to create images. In the intaglio techniques of engraving on metal, usually copper, lines are cut with a sharp, v-shaped tool to produce a line engraving. In an etching the metal is cut away with a tool along with the help of acid to "etch" lines. In order to control the acid, the metal is covered with a ground (resin) and the etching tool is used much like a pencil.

Lines can be used to create the effect of texture. Van Gogh was very fond of line and texture, using both freely in his paintings and drawings. He was especially fond of the marks made by a reed pen. The two illustrations are examples of his unique style with lines and textures.

All art has some kind of texture; art materials alone have texture. When painting was limited to a porcelain-like finish, visual texture or a simulated texture was carefully rendered in patterns with no visible brush marks. Although the finish is highly shiny and smooth, the simulated textures evoke a tactile response, appealing to our sense of touch. The glass-like finish alone has aesthetic appeal through our tactile reactions.

Contemporary artists often enrich the surface of their canvases with actual textures, such as sand or marble dust to produce a textured surface, and many textural devices are available with art tools and media. Because all art materials have some textural quality, artists immediately become involved with texture as soon as they select materials for their work.

Canvases can be purchased with a variety of textures; paper comes with various textures; wood and

masonite have their own unique textures. Paint can be applied to achieve varieties of textures, applied evenly and smoothly, in thick or uneven strokes, or dragged over the surface to create ridges.

Collages, constructions, and assemblages have increased interest and appreciation of texture as an integral part of painting-sculptural forms. Actual texture of objects rather than a painted imitation, actual shadows and actual depth rather than the illusionary imitation are often the preferred textures of today's artists.

Sometimes there is a difference between the meaning of the terms "pattern" and "texture," especially if the work is held to a two-dimensional effect. Pattern does not always pretend to have the tactile appeal of texture but may be used as a decorative design or as a repeated motif. Pattern is often used by abstract artists to add interest to the composition rather than to emphasize tactile responses of the viewer.

In sculpture, texture is a very vital and basic element of the art form. Much of the aesthetic response to sculpture is through the texture of the materials used by the sculptor. Our sense of touch is very much involved in our reaction to art, and the texture is the most "touch-feeling" response of all of the visual elements. We respond and enjoy the "feel" or the sensation of texture with our eyes, our skin, and our fingertips. No wonder museums have "Do Not Touch" signs and guards to keep a watchful eye on visitors.

Organizing Space

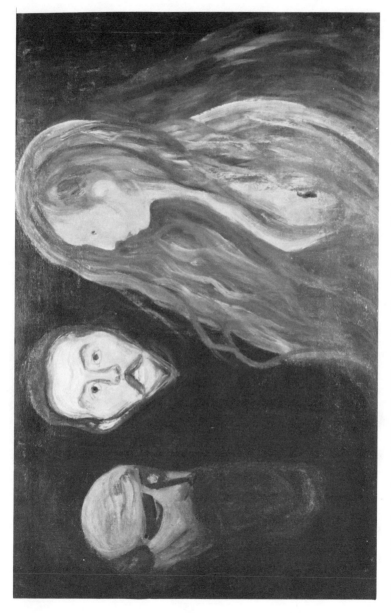

Edvard Munch. *Jealousy*, 1897. Oil, 30³/₈ X 47 in. The Minneapolis Institute of Arts, The Christina N. and Swan J. Turnblad Fund.

165

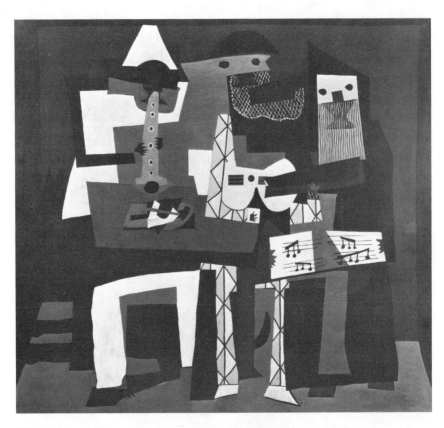

Pablo Picasso. *Three Musicians*, 1921. Oil, 79 X 87³/₄ in. Collection, The Museum of Modern Art, New York, Mrs. Simon Guggenheim Fund.

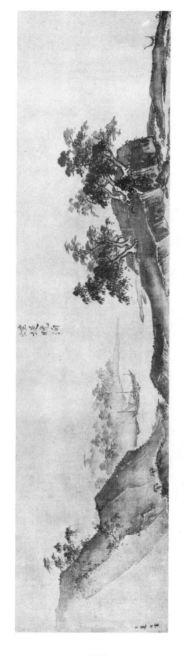

Hsia Kuei. *Landscape*, Chinese, thirteenth century. Ink on silk, 11 X 90¾ in. Nelson Gallery-Atkins Museum, Kansas City, Missouri, Nelson Fund.

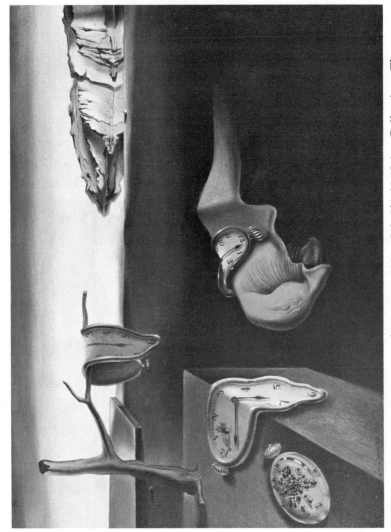

Salvador Dali. *The Persistence of Memory*, 1931. Oil, 9½ X 13 in. Collection, The Museum of Modern Art, New York, given anonymously.

Giorgio de Chirico. *The Soothsayer's Recompense*, 1913. Oil, 53½ X 71 in. Philadelphia Museum of Art, The Louise and Walter Arensberg Collection.

Unknown American artist. *The Sargent Family*, 1800. Oil, 38³⁄₈ X 50³⁄₈ in. National Gallery of Art, Washington, gift of Edgar William and Bernice Chrysler Garbisch.

Henri Matisse. *Dahlias and Pomegranates*, 1947. Brush and ink, 30^{1}/$_{8}$ X 22^{1}/$_{4}$ in. Collection, The Museum of Modern Art, New York, Abby Aldrich Rockefeller Fund.

Edward Hicks. *Peaceable Kingdom*, c. 1848. Oil, 17¹/₈ X 23¹/₂ in. Philadelphia Museum of Art, bequest of Lisa Norris Elkins.

172

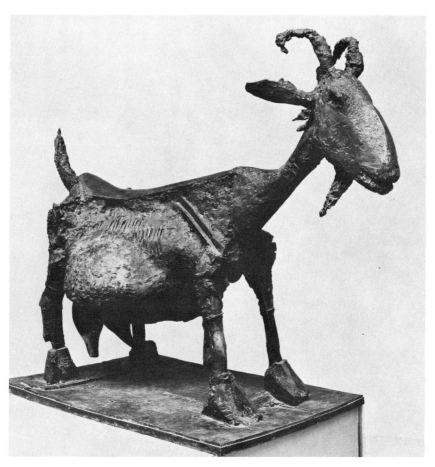

Pablo Picasso. *She-Goat,* 1950. Bronze, 46³/₈ X 56³/₈ in. Collection, The Museum of Modern Art, New York, Mrs. Simon Guggenheim Fund.

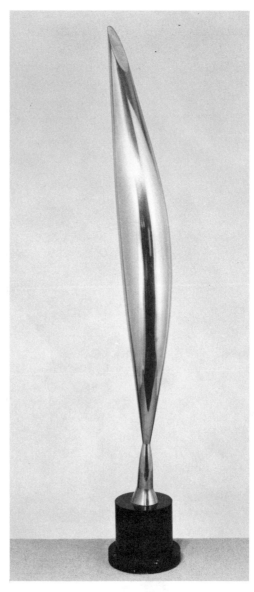

Constantin Brancusi. *Bird in Space*, 1924. Polished bronze, 49³/₄ in. high. Philadelphia Museum of Art, The Louise and Walter Arensberg Collection.

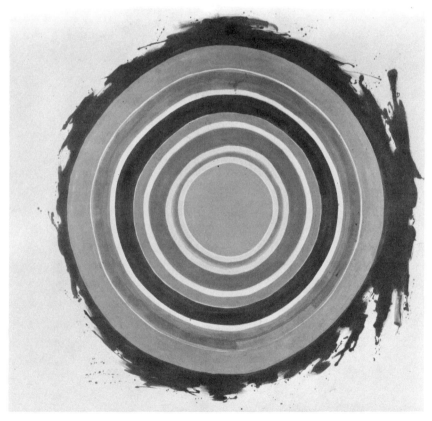

Kenneth Noland. *Bend Sinister*, 1964. Acrylic, 92³/₄ X 161³/₄ in.
The Hirshhorn Museum and Sculpture Garden, Smithsonian
Institution.

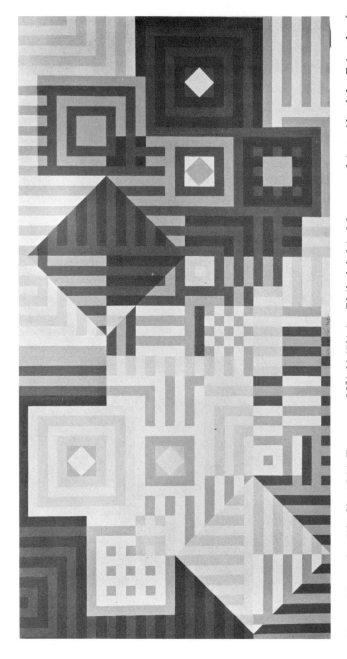

Victor Vasarely. *Kiu Siu*, 1964. Tempera, 22³/₄ X 45¹/₂ in. Philadelphia Museum of Art, gift of the Friends of the Philadelphia Museum of Art.

Max Beckmann. *Blindman's Buff,* 1945. Three panels: $73^{1}/2$ X 40 in., $81^{1}/4$ X $91^{1}/4$ in., $73^{7}/8$ X $41^{3}/4$ in. The Minneapolis Institute of Arts, gift of Mr. and Mrs. Donald Winston.

Jean (Hans) Arp. *Automatic Drawing*, 1916. Brush and ink on brownish paper, 16³/₄ X 21¹/₄ in. Collection, The Museum of Modern Art, New York, given anonymously.

Robert Matta Echaurren. *Composition C*, 1912. Pencil and colored crayon, 16³/₄ X 21 in. Courtesy of the Art Institute of Chicago.

Mark Tobey. *Forms Follow Man*, 1941. Gouache on cardboard, 13⅝ X 19⅝ in. Seattle Art Museum, Eugene Fuller Memorial Collection.

7

Organizing Space

S pace is a condition of life, vital to human existence: "The infinite deity which surrounds us and in which we are ourselves contained," in the words of Max Beckmann. And space is what art is all about, either the actual space of architecture or sculpture, or the implied space of painting and graphics.

Architects, city planners — every type of environmental designer — are vitally involved with space, constantly seeking new methods of enclosing or arranging space for human needs, both physically and visually. Because of the very vital human importance of environmental space, the final chapter discusses the subject in depth.

Painters and graphic artists work mainly with implied space instead of actual space. Working with visual illusions, manipulating the visual elements, they

181

can create the illusion of depth and space on a flat surface. Warm or bright colors appear to advance, and cool or grayed colors appear to recede. Value treatment, direction, placement, size of lines, colors, textures, and shapes combine to create visual illusions on a picture plane.

Although a separate chapter has not been devoted to a discussion on "shape" as an art element, shape is as essential in art as line, color, texture, and space. Shape is more easily recognized as an art tool by the art beginner because shape is the basic structure of all art forms. The surface upon which the artist works is a shape. The size and shape of the canvas or paper is fundamental and essential to the development of the completed composition. Shapes of picture surfaces vary with styles of painting; very large canvases and square canvases have been exceedingly popular with abstract artists; traditional artists usually prefer smaller, rectangle-shaped canvases.

Like all of the visual elements, shape has emotional qualities attached. Psychologists stress the importance of shape in the use of ink blot tests for evaluating emotional stability. Artists are also aware of the human association of relating shapes with objects and situations. Geometric shapes are viewed as intellectual, orderly, stable, dignified; curving, biomorphic shapes remind us of nature and the world around us. *Jealousy* by Edvard Munch emphasizes the importance of shape in an expressionistic style of painting.

Negative shapes, the quiet shapes surrounding the active shapes, complement and enhance the art much like the rests in music or properly timed pauses of actors. In Picasso's *Three Musicians*, notice the important

role of the negative shapes in tying the composition into unity and completeness. The negative shapes are as pleasing as the positive shapes. The flat-appearing, cardboard-like shapes limit the illusion of depth, and they are organized into an orderly, dignified composition, consistent, unified, and original. Picasso did not imitate or duplicate but invented a means of expressing a specific moment in time with abstract shapes and decorative pattern.

The painter working on a flat surface can depict various degrees of space that can appear to range from a flat space treatment like that of Picasso's *Three Musicians* to an illusion of deep or infinite space like Dali's *The Persistence of Memory*. The Chinese landscape implies space through the use of color illusionism. The Dali and Chirico are examples of deep space. A shallow, stage-like space is used in *The Sargent Family*. The illustration of Matisse is an example of a flat surface concept. (p. 171.)

Sometimes, the literal space of the viewer becomes a part of the art form along with the implied space of the picture plane. Collages, constructions, shaped canvases, attached objects, and relief sculpture are some of the types of work that protrude into actual space, thereby becoming a part of the viewer's immediate environment.

Because we live in a three-dimensional world, we unconsciously look for depth, even when viewing a two-dimensional surface that may have but a few marks, shapes, or colors upon it. It is natural for our eyes to perceive a space around the shape, color, or line, placing a background behind it. If two shapes overlap, we perceive one shape in front and one in

back. The illustrations of children's drawings are examples of space and depth implied with but a few lines and shapes.

The discovery many centuries ago of the illusion of the third dimension in painting was a major invention that marked a turning point in Western art. This century has witnessed a turning away from the illusionism of realistic imagery to abstract concepts. Artists have also explored the fourth-dimensional space-time continuum. Duchamp's *Nude Descending a Staircase* (p. 57), kinetic sculpture, and mobiles are fourth-dimension concepts. The all-over drip paintings of Jackson Pollock (p. 32) and Larry Poon's ellipses on large canvas (p. 34) give the viewer the illusion of a space-time-motion art in which there is no beginning and no end. The viewer standing close to this type of painting receives the sensation of "stepping into" the environment of the painting and becoming a part of endless, eternal time, limitless space. Since today's art is a kaleidoscope of artistic imagery and the self-expressive individual searching for reality and truth, the concept of arranging space is no longer confined to rules or limitations.

The nineteenth century defined rules for illusionistic space; consequently, a lot of this artwork does not have much of an original touch or individualistic mark of the artist, because personal interpretation and self-expression were not the main concerns. However, folk art was freed of imposed rules, since it was created by untrained artists, and because folk art retains individual expression and imagination, it appears very pleasing to our modern eyes.

America has some unique paintings made in col-

onial days and early days of nationhood, especially from the New England area. Itinerant, untrained portrait painters, called "limners," traveled the new country. They were very versatile: limners could decorate a carriage or paint a sign, barn, or portrait.

The portrait paintings of these early untrained painters are appealing through their honesty and sincerity. Relying on intuition, they created paintings similar to the illustration of *The Sargent Family* by an unknown limner.

Not only were these itinerant painters undaunted by lack of portrait training, but they were also very clever and inventive. During slow times and bad weather, limners often painted pictures of headless bodies clothed in the fashion of the day. Later, the prospective customer would choose a "body" and the limner would add a head in the "likeness" of the sitter. This bit of Yankee shrewdness and ingenuity saved both time and money.

As people became more prosperous, the role of portraiture for the limner disappeared, because too many considered the art work too crude and unrefined. Eventually the arrival of trained portrait painters from Europe replaced limners, since people wanted their likeness painted in the "proper manner."

The art style of limners is a type of folk art: shapes are simplified; lines and colors are used in a simple, direct manner. Seldom is there much shading, modeling, or attempt at creating illusion of realism. Often there is a great deal of surface pattern and detail; shapes tend to be flat and decorative. Sometimes they verge upon the point of abstract art as do the Pennsylvania Dutch designs and the art forms of the Shakers.

Another untrained artist of the period whose work has much appeal is Edward Hicks, an itinerant preacher who traveled in Pennsylvania in the early 1800s. Hicks isn't considered a limner, because he did not paint portraits. Instead, his paintings are based upon Bible stories; he presented them as gifts to those who gave him food and shelter. His *Peaceable Kingdom* is typical of many he painted, expressing his obvious concern and love for mankind.

Often Hicks' style and the limner paintings are referred to as "primitive art," yet the term primitive is misleading, since it has several meanings. In this case, primitive art means unschooled in art, as does the term "folk art," which seems more appropriate for the artwork. Grandma Moses, who became very popular in the 1950s, was a folk artist; often her art is referred to as "American primitive art."

Contemporary art stresses honest interpretation and individual self-expression with materials and organization. Every artist seeks, through a natural balance or harmony of his temperament and experiences, to develop a personal style of interpretation. Picasso's *She-Goat* is a good example of the artist's harmonious arrangement of unified shapes and textures into an honest and forthright sculptural form. Constantin Brancusi is equally successful with his *Bird in Space*, although the sculpture is an entirely different mode of expression. Simplified forms in space, shining, reflecting properties of the surface, the gentle curvature and fluid solidity of the material impart both tactile and visual pleasures.

Sculptors are involved with visual elements in much the same manner as painters or graphic artists,

except they arrange and organize materials into forms that occupy actual space. Thus, the reflection of light from the materials and shapes and the shadows cast from the forms are also visual tools of the sculptor.

The sculptural term "volume" usually refers to the interior space of a form, much like that of a teacup's interior. "Mass" is the solidity of the form. Concave areas are hollow or recessed areas; and convex shapes are the opposite, or a bulging shape. Planes are geometric forms that advance or recede into space or within the form. Because our world is three-dimensional, some viewers may feel a greater degree of empathy with sculpture than with pictorial imagery. However, everyone in this era is more space conscious than at any time in the past.

When Surveyor I landed on the moon in the mid-sixties, the age of space travel became a reality; human comprehension of space became a bewildering concept. The eeriness of viewing a moonscape became an actual experience, not a dream. Imaginative, surrealistic landscapes like Salvador Dali's *Persistence of Memory* are often used as comparative examples to describe the lunar world.

The space age has telescoped into full focus the awareness and the reality of the limited space we have on our own planet and the incomprehensibleness of the limitless space surrounding our world. The vital importance of space organization for our earth on a world-wide basis has never been of any concern until now, although humans have always felt compelled to arrange, organize, and rearrange their own immediate environmental space.

The ancient Greeks and Romans perceived space

organization in a specific manner; the Gothic builders, in another. Each historical period, with its attendant generations, has grappled with space concepts, but the present-day viewpoint is vastly different from any of the past.

Today's space consciousness not only includes concepts of environmental space organization, but also visual imagery experiences of previously unseen areas of space. Television sets show photographs of faraway places, and views of aerial pictures of our earth, moonscapes and distant planets. Telescopes, electron microscopes, X-ray machines, underseas cameras are able to probe nearly everywhere, increasing our visual experiences beyond human comprehension of past generations. The list could go on and on. All of the visual imagery referred to in the list are projected by machines, but man's creative mind has occasionally imagined or forecast a future that has become a reality.

Dali and other surrealists had created moon-like paintings long before man actually saw the moon. Also, artists invented perspective techniques to paint photograph-like paintings centuries before the camera became a reality.

Whirling, vibrating, seemingly endless space brought about by using discords, explosive shapes, and harsh colors were space concepts of abstract painters of the forties and fifties, indicating the chaotic conditions of the times. Vibrating, fluctuating, deep space continued in the sixties with optical art. Much of op art gives the appearance of having been spawned by a machine. It is based upon perceptual patterns and extreme color contrasts, and the viewer is led into a frantic, dizzy path, reeling into space. *Bend Sinister* by Ken-

neth Noland is a type of optical art based upon illusionism and vibrant qualities of colors. *Kui Sui* by Victor Vasarely is another example of geometric patterns, color contrasts, fluctuating lines and shapes.

Max Beckmann's large triptych painting, *Blindman's Buff*, portrays man's conflicts and inhumanity in a frenzied crowding of space, and the illusion of people tumbles from the picture plane into the quiet, controlled space of the viewer.

Beckmann used recognizable subject matter in organizing his composition, but many contemporary painters and graphic artists prefer to use abstract shapes, to create an impression rather than a specific situation or experience. Through spontaneous, intuitive organization of space, controlled by intense emotional involvement, commitment and sensitivity, the visual imagery becomes a statement of abstract ideas.

Abstract imagery is not a new art concept. On the contrary, abstract art has flourished for centuries in many cultures of the world. Because Western thought has become ingrained with centuries of viewing imitative imagery, many continue to believe abstract art is a new visual invention.

The illustration of Arp's *Automatic Drawing* shows a dada concept of organizing space into a pleasing composition with the use of accidental lines and shapes under the subconscious control of the artist. Matta Echaurren's *Composition C* is an example of abstract imagery and space organization in which strange, imaginative shapes and fluctuating, explosive space treatment create the concept of a total experience in art viewing, not a specific situation or place in time. The drawing was made in 1912.

Mark Tobey made a small tablet-size gouache painting in the early forties, *Forms Follow Man*. In the visual abstract concept, space is crowded with machine-like shapes—humanity is absent from the scene—only machine parts remain. The painting is a significant calligraphic treatment of space using abstract imagery typical of this century.

Contemporary artists continue to explore ever-widening horizons. In the past, changes were slow in all human endeavors. For centuries, the primary goal in art was to gain an optical mastery of imitating nature, of portraiture. Now, with humanity in the space age and nearing the twenty-first century, man and his art forms have the challenge of portraying the current concept of reality and seeking new concepts.

Reading about art and looking at art in museums, galleries, or wherever original art is displayed are steps toward learning to see our world with trained vision. Extending visual experiences expands visual awareness. But not all art forms are in museums; art surrounds us in our everyday world waiting for us to become aware of its existence.

PART III
ART
AND
AMERICA
THE
BEAUTIFUL

Art Awareness

and

Our Environment

Frederic Edwin Church. *Scene in the Catskill Mountains*, 1852. Oil, 31⁷/₈ X 48¹/₄ in. Collection, Walker Art Center, Minneapolis. Photograph by Eric Sutherland.

Washington Allston. *Moonlit Landscape,* 1819. Oil, 24 X 35 in. Courtesy of Museum of Fine Arts, Boston, gift of William Sturgis Bigelow.

John Trumbull. *The Declaration of Independence,* 1789–94. Yale University Art Gallery. (Although Trumbull's painting measures only thirty inches wide, there are forty-eight portrait figures in it.)

George Catlin. *Buffalo Hunt*, 1863. Oil, 19 X 26½ in. Joslyn Art Museum, Omaha, Nebraska, gift of W. F. Davidson.

8

Art Awareness
and Our
Environment

The number of paintings or sculptures created in a society does not insure a better quality of life or a better world. Rather, it is the visual awareness of an artistic society brought about by the understanding of the language of art that opens the eyes of the people. Thus, art awareness can bring about action concerning urban deterioration, threats to our architectural heritage, visual blight, and the ugliness of pollution and litter. Art awareness leads to upgrading the quality of the environment.

People who enrich their lives with awareness and sensitivity to art are also sensitive to the environment around them, both the natural world and the man-made world. A deep aesthetic feeling cultivates inner harmony which is vital to the functioning of a keen mind. Aesthetic responses are precious to all human

beings. Art experiences open our eyes to perceive, stretch our minds, and feed our imaginations and our creativeness.

Most educators believe that nearly everyone has the natural endowment to become a creative person. But creativeness, as an innate instinct, needs encouragement and nourishment, and art is a subject that encourages creativeness and awakens awareness.

Awareness of our environment is one of the central characteristics of the creative process. By increasing perception through art experiences, our senses become more refined and acute to our surroundings. The variety of lines, shapes, and colors that surround us evokes feelings within us, but we miss the empathy that we feel with our environment if we look upon the world with dulled eyes.

Visual awareness is the quality that makes the difference between "seeing" and "looking." We think we "see," but often we are not really conscious of many of our visual impressions. Our eyes and minds become dulled and conditioned to comprehend only that which we want to see. A blunted visual perception allows visual blight to exist, with deterioration and decay taking over our natural and our man-made worlds, because we "shut out" the view from our eyes and our minds.

As we become more sensitively attuned to the language of art, we become more attuned to life and the world around us. The qualities that go into making a more artistically oriented society are qualities that will enrich our lives and add meaning to our existence. Art can supply the visual awareness, imagi-

nation, and creative thinking that are necessary ingredients for working toward the common goal of improving the quality of the world.

To claim that art endeavors will promise survival to man is exaggeration and folly. But art thinking and art theories are qualities that will help turn our society away from exploiting our planet. The spirit of art consists of desirable characteristics that can lead a society into creative thinking about environmental problems.

Our nation, indeed, the world, will have to re-examine values and assign priorities. Some very radical changes will have to take place, and the people will have to want to change. In pursuing the shallow goals of materialism and senseless consuming, we are depleting our natural resources and polluting our air and water.

Because this hemisphere was the frontier for the Old World, we have always had the attitude that there was more on the horizon—more land and more riches. However, this century brought the realization that the frontier is closed. The space age has brought further realization that the world which had always seemed so large is nothing but a tiny speck in a gigantic sea of blackness. We have to take care of our only home, because there is no foreseeable home any place else.

Much of man's environmental problems stem from the past concept of his relation to nature. Western man has always viewed nature as a thing that he had to conquer and subdue in order to live with the life-giving bounty of the world. Man is by instinct a builder and a designer and is constantly wrestling with his environment to reshape it to better suit his needs. In

the past, much of the damage done to nature by man was reparable; then he invented machines to help him "conquer nature."

Man's wants are shaped and determined by the society in which he lives. Man's wants are unlimited if he gives in to insatiable greed. Needs must be met for survival, both physically and mentally, but wants can be fewer. Most of us learn that the qualities that give deeper meaning to life are not found by gaining more things of the materialistic world. Accumulating things is not what gives life meaning.

Since we now have the vital knowledge that man is a part of the total universe—a link in the interrelated chain of life and survival—we have to change our ways. Since man is the creature on this planet who can perceive the destruction he is causing, he must assume the responsibility of stewardship and husbandry. This knowledge has to be the basis for all of our priorities. Everyone must be educated, adults as well as children, in these environmental facts. It cannot be a fad—here today and gone tomorrow. Everyone will have to change his or her sense of values. Artists and scientists will have to define and deepen their values with respect to our environmental problems in order to become leaders in educating the eyes and minds of the people to the world around them.

When we view landscapes painted by artists such as Church or Allston of the last century, and then compare the beauty of the past with the ravaged land, dying rivers, and dead lakes of today, we cannot help but become avid conservationists.

During the thirties, a well-known cartoonist, Jay "Ding" Darling, did some important crusading for

conservation with his daily newspaper cartoons. "A picture is worth ten thousand words," and those who have the talent, imagination, and wisdom to educate the public with such visual images can start social pressure to bring about important laws regarding our environment.

Today, television is one of our major visual educators, and it could become the most valuable tool that technology has given us in the fight to preserve our world. There has been some important work in educational films about environmental problems, but the subject must be treated to appeal to all levels of audiences. The subject of our environment should become as popular on television as football and soap operas.

Our total environment is made up of our man-made artificial world and the natural world. An ugly environment causes ugliness within us that is as destructive to our well-being as the damages we are doing to our physical, or total, environment. Visual blight, or sight pollution, affects our mental health.

Our surroundings determine our morals and self-esteem. Man is a creature sensitive to his surroundings, because his emotional attitudes and intellectual outlooks are shaped by how he feels about his surroundings. A visually pleasing home, neighborhood, city, and country or, in contrast, a world filled with litter, filth, and decaying ugliness form our self-concepts and our social values.

Humanity reacts to colors, shapes, values, and textures of the patterns and shadows of the visual world. Visual pleasures stimulate the inner spirit of man. The beauty of the natural world and artistic design and arrangement of the artificial world add pleasure to our

lives through all of our senses. For example, the visual arrangement and appearance of food add pleasure through visual delight, thereby enhancing the taste of the food.

When we were an agrarian society and lived close to the land, we felt more a part of nature. Living plants and trees, wildlife, and the song of birds are an essential part of life. Our natural world contributed to our feeling of well-being. We are discovering that this need within us cannot be satisfied with glass, plastic, concrete, and asphalt. The beauty of nature offers us rest and inspiration and restores our spirit. Most of us realize the recharging powers of nature when we seek the outdoors and the wilderness for our vacation and leisure hours.

For many centuries, the Japanese people, crowded on tiny islands, have understood this need within man. Their homes and gardens are looked upon as one free-flowing unit of space design. Indoor space and outdoor space are considered in the total organization. Many Japanese households have within the home a tokonoma, which is an alcove where an object from nature is artistically arranged. The object may be a branch, a rock or a simple flower arrangement. Another island, England, planted and landscaped virtually the entire countryside during the eighteenth century.

Ugliness, pollution, and dismal surroundings can create within us a state of anomie, which is a state of indifference, weakened standards, and a complete apathy to surrounding conditions. Intellectual and emotional growth is stifled in such an environment.

Human senses are dulled by the noise of machines,

the foul smell of pollution, and the crowding within a jungle of repulsive filth and litter. Under such conditions, man insulates himself by becoming callous and insensitive, blind, deaf, and unfeeling toward anyone or anything around him. Visual ugliness demoralizes by corroding human conscience and eliminating compassion for fellow men. Small wonder that blighted areas have high crime rates.

Human beings have rarely been satisfied with either their natural world or their man-made environment. Since the beginning of time, mankind has been redesigning his surroundings to express his ideas and to better fit his needs.

In the preceding chapters, the discussion was confined mainly to painting and sculpture. Although architecture is involved with engineering problems and is created to serve a utilitarian purpose, much architecture is a work of art. Like all meaningful art, it delights the eye and expresses ideas. Every art expression has common goals and basic concerns with visual processes, yet each work of art produced is unique.

Architecture has always been concerned with factors that differ from the other visual arts. Structural factors, building materials and engineering problems, space manipulation, and environmental factors are vital to architecture. But like the painter and sculptor, the architect is concerned with the design of shapes and space. He deals with color, line, texture, planes, and masses. He is concerned with balance, proportion, harmony, and rhythm. As one aspect of art, architecture, like all art forms, expresses the spirit and ideas of the time in which it is created.

In the United States, in our haste to conquer a conti-

nent and build cities, we unhappily neglected much of the visual appeal of architecture. Too frequently, the American attitude toward architecture has been that a building must be functional and serve a purpose, with visual appeal and environmental factors considered of least importance, if considered at all. Architecture, more than the other arts, is tied to the purse strings and taste of the owners of the building. Americans often elected to leave culture and aesthetics to other nations.

Naturally, in the beginning, when this country was settled, the first concerns were to build temporary dwellings with any available materials at hand. Later when more permanent shelters were built, they were patterned after the simple cottages of the colonizers' European homeland. The Spanish colonizers built forts and missions, using materials at hand, with native American labor and building techniques.

Later, the elegant buildings in the English colonies were miniature copies of English architecture. The style is often called "Colonial Georgian," after the three Georges who ruled England during those colonial years. The most impressive of the Colonial Georgian style is found in Williamsburg, which was the early capital of Virginia.

After the Revolutionary War, American architecture and artistic ties continued with the style and tastes of European trends. We did not invent new forms but preferred importing our building ideas.

At the beginning of the 1800s, Neoclassic art, or the Greco-Roman style, was the favored revival in Europe. In America, we call the Neoclassical revival the "Federal Style." Many of our government buildings and state capitals were designed in this style.

For most of the nineteenth century, Americans were content to imitate European styles of architecture. As the century progressed and the nation became rich, wealthy citizens built copies of Romanesque fortresses, Spanish monasteries, Italian palaces, and Gothic castles.

The term "Victorian," after Queen Victoria of England, is often used when referring to the Gothic revival that was popular during the end of the last century. Sometimes this age is called the "Gilded Age," or the "Gingerbread Age," because of the arches, peaks, towers, and the enrichments of scrolls, carved embellishments, bay windows and use of stained glass.

At the beginning of this century, new materials and new construction methods were used, but the old building styles were copied. Iron and steel constructions were covered with stone in an attempt to make the building look like an all-stone building.

Following World War I, all art forms, including architecture, broke away from the past to express the ideas of the technological age. Technology and expanding commerce called for new kinds of buildings. Louis Sullivan, an important pioneer of the modern skyscraper, did not believe in hiding the structure of the building. He believed that a building should be an honest expression of the construction methods and materials used. The skyscraper became a monument to the age of technology and scientific progress.

In our haste to keep up with industrialization, we let cities grow with little planning. In many cases, too many tall buildings were erected with little thought given to the hoards of people living within the congested areas. At first, designers were concerned with the interior space and how the buildings could per-

form various functions with greatest efficiency. Often, the exterior of the building followed the function of the interior, with little regard to the exterior form except for a few embellishments and decorative touches. Many dreary industrial and public buildings were constructed under the misunderstanding of Sullivan's famous theory, "form follows function."

The human element was almost forgotten when the skyscraper was born. Although the tall structures solved an economic problem with efficient use of space, they created dark, airless canyons. Eventually zoning laws required space around tall buildings, and the later skyscrapers became stair-stepped, cubistic blocks. From the layered building to a thin glass-slab type was the next step. Now, there is an attempt to deal with the problem by relating and integrating groups in which there is planned openness with miniature areas of natural surroundings of trees and grass.

During the forties and fifties, the American landscape was influenced by the Bauhaus architects who migrated to this country. Architects such as Walter Gropius and Mies Van der Rohe created buildings of precise, geometric cubes, which became the mark of the International Style, and the stamp of modernism. However, some reacted against the cold formalism of the International Style.

Frank Lloyd Wright and his followers have emphasized organic unity as well as functionalism. Wright used an inventive approach to structural problems with a rich feeling for materials and forms in relation to the structure's environment. His man-made forms related to the site and became an integral part of the natural landscape.

Although Wright's disciples, representing Organic Architecture, and the followers of the International Style are at extreme ends of designing concepts, they both agree that the human element is important. The two concepts have had major influence upon the American scene, but contemporary architecture is very diverse, going in many varied directions in style and use of materials. R. Buckminster Fuller and his geodesic dome, Le Corbusier with his vertical city garden units, and the new era of sculptural concrete and sculptural symbolic forms are recent and dramatic strides in architecture.

Although the ancient Roman builders used concrete, it has finally come of age as a material offering many new possibilities. Reinforced (ferroconcrete) concrete and pre-stressed concrete are very strong, relatively inexpensive, and capable of being cast into many shapes.*

In our society many architects are creative, ingenious, and artistically oriented. They are aware of the human aesthetic needs in relation to the total environment. They are vitally aware of the visual relationship of the man-made world and its relationship with the natural world. But too often, ignorance and profit, parading under the disguise of "practicality" and "efficiency," dictate the visual quality of our buildings and our cities.

Our modern age is symbolized by gigantic skyscrapers, looping expressways, and amazing engineering feats. We have new building materials and new

*Ferroconcrete is concrete reinforced with steel rods or steel mesh, and pre-stressed concrete is concrete hardened around stretched steel cables. Because of the strength and flexibility of the processes, a great variety of building shapes can be designed.

methods and ideas to use conventional materials in exciting ways. But some American architecture is not pleasing to the eye. Unfortunately, too much is trite and ordinary, lacking imagination and environmental planning. However, there have been some radical changes in architecture in the past decade, and the future promises some exciting and original designs with creative and unusual concepts in the use of shapes and space.

Slowly, we are learning that a society with art awareness, or, to consider the other side of the coin, the lack of art awareness, is a major influence in shaping our environment.

In our haste to conquer a continent, we Americans were inclined to leave beauty and culture to other nations. American tourists traveling to foreign countries are impressed with the architecture, the tree-lined streets, flower beds, and flower-filled verandas.

Our cities, growing in all directions, have engulfed surrounding towns and eradicated rural landscapes. They have become super-cities of ugliness and trite conformity.

Lack of planning, economic problems, and poor urban management in renewal projects have resulted in repercussions of visual pollution as well as a polluted atmosphere, unsafe water, and ecological damages. Complex social, economic, and political factors have compounded the problems. Expressways and ghettos of crowded human masses have caused immeasurable problems. The more we strive to reach the popular concept of the future, the more we compound our environmental problems.

Yet, however we view the city, it is man's symbol of

civilization and his ability to reach magnificent heights of achievement. Each civilization, in shaping its environment, is forever reaching for utopian perfection. Each society has wrestled with the problems of controlling space and its environment, and each has found some solutions. The sprawling, living organisms of gigantic cities will never reach perfection any more than man himself can reach a perfect earthly state.

But, through perception and awareness of the relationship of our artificial world to our natural world, human beings can create structures that meet both our social needs and our visual needs. With the guidance of creative visionaries, our legacy of humanism will survive, and the visual arts will play a large part in the total picture. Those people who are aware of art principles and who are artistically oriented surround themselves with the beauty of nature as well as aesthetically pleasing buildings and objects. Artistic people are visually oriented and have a deep desire for beauty in their environment. In crowded areas, imagination and artistic creativeness can bring about small areas of visual beauty and delight for the eyes. Small parks and miniature spots of natural beauty along with man-made art—sculpture, mosaics, and murals—could be planned for everyone to enjoy. "A thing of beauty is a joy forever," wrote Keats.

Americans are discovering that pleasing visual surroundings, planned for viewing by people, as well as filling space, deepen human values and enhance self-esteem. We are becoming aware that some kind of direct contact with nature and art promotes a better mental outlook. Beautification committees made up of professional artists and designers are vital to all build-

ing and renewal projects. Pleasant surroundings elevate civic pride and foster keener perception and intellectual advancement.

An artistic nation preserves art of the past in its museums, shrines, and cathedrals; but most importantly, it surrounds itself in daily life with beauty and art.

If a nation as large, wealthy, and diverse as ours held but one common goal to work toward—to obliterate visual pollution—it would help solve many of the problems we are faced with in our polluted world. Garbage, litter, junk, ugly signs, decaying buildings, and blighted areas do not need to deface our landscape. Everywhere in our land, we could become "America the Beautiful."

It is rare for most Americans to view their own buildings as art. Too many have the narrow view that art exists only in museums. Apathy, through lack of art appreciation and the opinion that history must not stand in the way of progress, has destroyed much of our cultural heritage.

One of the important functions of art is the stimulation of new ideas, but art also plays an equally important role as a stabilizer in the society by preaching for preservation of art of the past. Human identity with past human artistic endeavors acts as a stabilizing influence.

A mobile society like ours needs a sort of "security blanket" as a link with the past. In this world of whirling changes, with some of the technological innovations not understood by many, artistic ties with the past are pleasing reminders that we are humans and not machines. Long-standing landmarks of fa-

miliar architecture give us something to cling to and identify with.

Art awareness that seeks to preserve or salvage architecturally significant structures and objects of the past is not advocating "the good old days" attitude or yearning for another time. Art takes much from history, as does every field. Only the egotist believes each new generation begins fresh, with new ideas, and that ideas of the past are time-worn or worthless. Preserving historic buildings and treasures of significance saves an actual visual history for future generations. Appreciating the creativeness and artistic achievements of humans of another era inspires and nourishes our instinct for creativeness.

No one would believe that it is possible to advocate preserving every structure of the past that is standing. In our local areas, as well as in the nation, we have to evaluate that which is architecturally, artistically, and culturally significant to preserve. Once a valuable treasure is destroyed, it is lost to us forever. Often the flavor is lost in attempts at copies or authentic reproductions.

Of course, it is not feasible to save every important old structure as a museum. Many can be salvaged, put to use, and continue as an important historic site. Too often, we have wantonly destroyed the architectural styles which were representative of the rich and diverse contributions made to American life by differing cultures and ethnic groups in our past.

Fire and other natural causes have destroyed many of our major landmarks, but most of them have been destroyed because of ignorance, greed, or an apathetic

public. Urban renewal programs have ruthlessly mowed down everything in their paths. Every time a landmark falls in the name of "progress," or for a highway or a parking lot, a part of our past is destroyed.

Until now, many Americans have not given much thought to preservation or conservation. Until now, there has never been much yearning for beauty in our surroundings. We have believed something new was waiting for us over the horizon, and we turned our backs on the old which we left behind us. Finally, many are beginning to realize that we have to live with what we have as well as with preserving that which is valuable from the past. As a nation, we are maturing and beginning to see what we have not noticed before, and we are readjusting our values.

Conclusion

Of art's many pleasures and benefits, undoubtedly the most rewarding is the development of visual awareness. It is visual awareness that opens one's eyes to really "see" the world around one—both the natural and the man-made world. Because there is a difference between really seeing and merely looking, visually sensitive persons are acutely aware of visual impressions. Sharp-eyed, they see papers and garbage polluting roadsides, parks, and city streets. But "dulled eyes," unconcerned with seeing, may not notice the ugly litter because they have shut off much of their visual sensitivity.

People who enrich their lives with awareness and sensitivity to artwork can often retain, even sharpen, the visual alertness they had when they were wide-eyed, curious children. Since visually alert persons actually see their surroundings, they often become crusaders against visual blight and environmental deterioration.

Education in art is valuable because the visual training that art teaches helps strengthen visual perception.

Those trained in art tend to become more discriminative of their surroundings because their senses have become more refined and acute. Education in art can bring about action because increased awareness among the people about their blighted environment can lead to innovative solutions.

From prehistoric times, mankind has used pictures to illustrate and interpret the real world. Ancient cave paintings in Spain and France, wall paintings in Egyptian tombs, and frescoes excavated from ruined cities such as Pompeii are visual examples of earlier concepts of the world.

Throughout history, artists have created artwork that taught others to see the images of the world around them; at the same time, their art often encouraged the viewer to look toward a better world. Greek sculpture and architecture glorified the human race and its potential in this visible world. In contrast, Gothic art looked toward heaven and the spiritual world. Gothic cathedrals stretched to the sky, trying to reach into heaven; painted and carved Gothic angels and saints pointed the pathway to God. Although much of Renaissance art remained in churches, artists managed to combine the spiritual with the visible world.

Leonardo da Vinci was one of the first artists to portray a real flesh-and-blood woman living in the visible world. The landscape in the background of the *Mona Lisa* is probably far more important to the spirit of the painting than her smile. Yet, most viewers cling to the myth of the smile.

Today, much abstract artwork is concerned with teaching visual awareness. Abstract painters tend to

work only with color, line, shape, and texture and to eliminate story content altogether. They believe realistic imagery often interferes with the viewer's development of visual awareness. That is, many casual viewers do not develop a deep visual awareness if they look only for story content in an art form.

Pop art often defines environmental problems. Unfortunately, since pop art resembles advertising art, its subtle messages and irony may be lost on viewers who are surrounded by advertising and materialism.

Two other art media, television and film, could become valuable tools in teaching environmental awareness, since they reach more Americans than almost any other form of communication. Creative filmmakers could lead viewers into a deep awareness of the deteriorating quality of our environment. Meaningful awareness could certainly lead to public action.

However, becoming deeply concerned about our planet means everyone will have to *want* to change. At this point, too many pay only lip-service to the necessary changes. We know that willingness to re-assign priorities in our lifestyle is a challenge to most of our values. To bring about the transition, creative film artists can reinforce the ideas with their artwork. Works of art have helped people define their values and set their goals in the past. Today, art freed from commercialism could lead the crusade.

Paintings on a wall, sculpture in a courtyard, and magnificent buildings enrich our lives with visual pleasure. But most importantly, people who become oriented toward art become visually aware of their surroundings. Visually sensitive people see the blight and pollution around them. Art can lead the way to a

world where people are deeply dedicated to the well-being of our planet and an aesthetically pleasing environment.

Beautiful works of art do not guarantee mankind's survival. Science and technology have flourished this century, but what about the next century and the one after that? Can technology promise our survival?

The creative nature of a culture is mirrored in its accomplishments, whether they are in art, science, or technology. The final product or outcome becomes, in effect, an extension of ourselves. One aspect of man can create marvelous art, yet another can create lethal weapons.

With a better balance of art with science and technology, cannot the creative and intellectual pursuits of mankind be directed toward creating a future in which all people of the world are concerned with humanness, the well-being of our planet, and an aesthetically pleasing world?

If the reader has begun to question and think about the role of art in society, then this book has accomplished the purpose for which it was written.

Index